LETTERING
AND
LETTERING
DISPLAY

LETTERING
AND
LETTERING
DISPLAY

William Mann

VAN NOSTRAND REINHOLD COMPANY

New York Cincinnati Toronto London Melbourne

Van Nostrand Reinhold Company Regional Offices:
New York Cincinnati Chicago Millbrae Dallas

Van Nostrand Reinhold Company International
Offices: London Toronto Melbourne

Library of Congress Catalog Card Number: 73–18921
ISBN: 0 442 30040 9

Designed by William Mann

This book is set in 11 pt Monophoto Bembo. Printed
by Jolly & Barber Ltd., Rugby. The book is bound
by the Ferndale Company, South Wales.

Published by Van Nostrand Reinhold Company Inc.
450 West 33rd Street, New York, N.Y. 10001 and
Van Nostrand Reinhold Company Ltd., 25–28 Buck-
ingham Gate, London SW1E 6LQ.

16 15 14 13 12 11 10 9 8 7 6 5 4 3 2 1

ACKNOWLEDGMENTS

The material for this book has been gathered together
from odd places over a period of several years, with
no thought of publication until quite recently.

During that time some examples have changed in
appearance and others have simply disappeared.

My thanks to:
 Plymouth Museum and Art Gallery,
 Plymouth Public Library, and
 Geoff and Dianna Clarke
for permission to include items from their collections,
and for assistance from:
 Brian Preston
 David Sentenacq
 Colin Nunn,
 James Anderson, and
 Christopher Smith,
and to the owners of all other examples recorded and
assembled between these covers.

Dedicated to my son Richard whose concern for good
visual communication is as great as my own.

CONTENTS

PRINT Books
 Music Sheets
 Theatre Posters
 Letter Headings

FOLK Samplers
 Greetings and Commemorative
 Cards
 Graffiti

ENTERTAINMENT
 Gallopers
 Organ
 Processions
 Public House
 Theatre

INDUSTRIAL
 Barges
 Wagons and Lorries
 Tractors and Steam Engines
 Trams
 Miscellaneous Castings and
 Street Furniture

ARCHITECTURAL &
COMMEMORATIVE
 Buildings, Warehouses and
 Temporary Structures
 Headstones
 Shop Fascias and
 Shop Windows

The contents are not arranged in the order as shown above.

This crazy bus is painted in rainbow colours and is full of appeal.

INTRODUCTION

As a student I was privileged to see the late Edward Johnston demonstrate calligraphy by writing on a blackboard with chalks of varying widths. The resulting explosion of beautiful letter forms, isolated words, short sentences and single initial letters, so freely executed with the unconscious grace of creative professionalism, has left an impact on my memory that will always remain.

Only the very dedicated student of calligraphy could hope to stand on the threshold of such scholarship that is attained after years of constant practice, hard work and self-discipline.

I was not to be so dedicated. Unwilling to face the imagined drudgery of lettering practice complete with carefully prepared quill pens or reeds, my interest in calligraphy waned.

And now, considerably older and perhaps wiser, but chiefly concerned with training students for a career in communication design, my association with letterform is renewed. This very basic art is in short supply at some schools and non-existent in others. Prospective students for this course are interviewed with a portfolio of their art work, and any bias towards lettering could be an advantage. At least it would indicate that as individuals they are not completely against the disciplines involved when producing a piece of lettering.

The contents of the portfolios are varied, with examples of still life, costume life, landscape, abstract painting and a few portraits of fellow pupils. Plenty of paint, obvious enjoyment, a few replicas of pop idols, and an occasional poster.

Rare exceptions to the general rule provide examples of attempted calligraphy with a pen, and occasionally a few words in pencil or poster paint in an assorted letter form that is related albeit somewhat distantly to a style seen elsewhere.

At infrequent intervals there appears an offering of early English script, laboriously produced and proudly mounted and framed – an attempt to impress with its supposed hidden talents and promise for the future.

Each successive year produces a new batch of interviewees armed with their creative work and each year I continue to be surprised by the small interest shown in letter form and lettering generally. This section of the art room curriculum is so obviously a non-starter in the race for the 'best performance-with-least-pain' stakes. It is only human to bend with the majority and offer a semi-realistic-cum-abstract approach, which undeniably produces some exciting results. Unfortunately it leaves a void in the practical introduction to communication design, which can also produce equally exciting visual material.

I do not think that a liking for lettering can be gained without some effort. It is something of an acquired taste that should be sampled with a touch of sauce to remove or camouflage the supposed dullness. The week-by-week programme tends to allow precious little time for research. This is a pity as there are avenues of exploration which could be followed that are neither too time-consuming nor too difficult.

Instead, and all too often this is the case, lettering exercises are set that demand both patience and conscientious effort beyond a pupil's capacity and concentration. These are usually ploughed through with set lips and a cramped mind, and in spite of this may show some promise of ability and the beginnings of skill. Should the experiment extend to over-long periods of time, the work will reveal carelessness and non-involvement.

The best examples of lettering that schools have to their credit are to be found amongst the rare and well organized initial letters and pithy messages that appear on and under desks. Carved and inked with a firmness that suggests a single-minded purpose, not lacking in spontaneity, directness or skill in spite of the work having to be carried out in secret!

The adherence to neatness and uniformity in the practice of lettering is due to those mediaeval pen craftsmen, followed by the early printers, who with the juxtaposition of wood types performed such marvels of book work in their efforts to supersede one craft by another.

However creativity must not be sacrificed to neatness. We are too much influenced by the mechanical regimentation of groups of letters as we know printing today. It will never open the broad vista of visual delight that the craftsmen offered to young and old.

To the discerning, lettering of character will always give great pleasure. To be one of the discerning is not difficult and with a rational approach a new area of communication awareness can be uncovered.

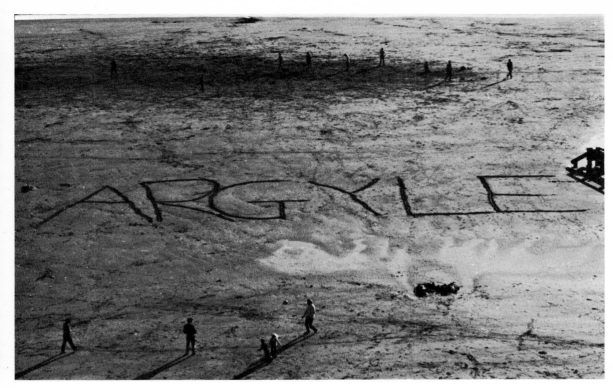

There is a certain set of criteria for the judging of letters. A selection of letter forms, either dramatic or subtle, that display the quality of shape, colour, weight, fitness for purpose and design skill, are not the prerogative of any one age. They are the direct result of specific requirements and the supplying of those requirements – the solving of a particular problem. Problems requiring diverse solutions are still with us, but as there are more of them there are also many more less satisfactory solutions. It is ironic that with such an abundance of lettering examples surrounding us today, we accept practically all without questioning their suitability.

So to this book. Interest in lettering could arise from the lettering alone, but that may be insufficient to sustain study for a lengthy period with groups of pupils who are not consciously destined to be designers.

For this reason, I have chosen specific examples of everyday things that are still to be found in most places touched by Western civilisation during the past 150 years.

Boys and girls of all ages will be interested in canal barges, steam tractors, stage coaches, veteran cars, fairground roundabouts, Victorian samplers, Edwardian greetings cards and other examples of folk design that are not too difficult to discover. These examples of a historical past are also touched with some glamour, and the best are eagerly sought after by collectors.

In their own right, most of the items mentioned have some strong sense of appeal; their shape, movement and noise when in motion are all different from what we see today. The surface decoration and lettering shows remarkable restraint and considerable ingenuity.

It is the purpose of this book to make the acquaintance of the lettering of the Victorian and Edwardian periods with its exuberance and invention, and to explore, consider, record and develop that lettering and its decorative elements that gave enrichment then and continue to do so today.

Tradition has it that the lettering shown here was cut by sailors in the second half of the nineteenth century. The lettering is found in a cave known locally as "The Grotto", on Whitsand Beach in Cornwall.

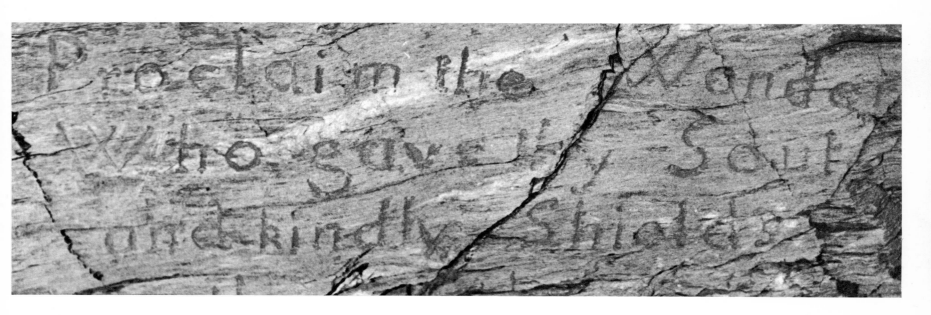

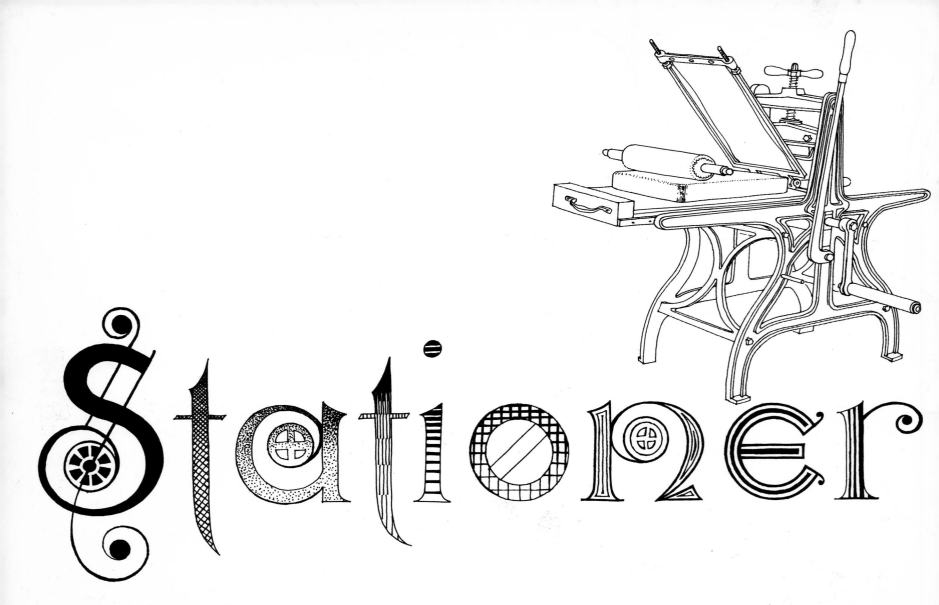

Stationer

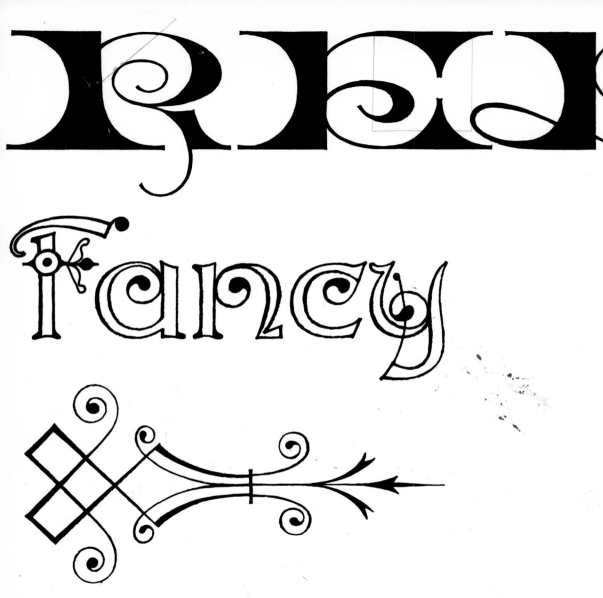

Many Victorian cast-iron lithograph proofing presses were decorative pieces in their own right. Fine machines like this one must have been an inspiration to the artist and printer.

Any design or piece of lettering could be transferred from specially coated paper on to a litho stone with great ease. This allowed artists a freedom governed only by their ability to use pens, brushes, litho chalk and ink.

The words RED and FANCY are characteristic of this freedom. The decoration added to each letter in STATIONER reflects the surface texture achieved in many examples of this craft.

RED and PAINT show the curved forms and some of the surface treatment drawn to a more restrained and legible form, whilst retaining the element of adventure easily achieved with a pen or brush.

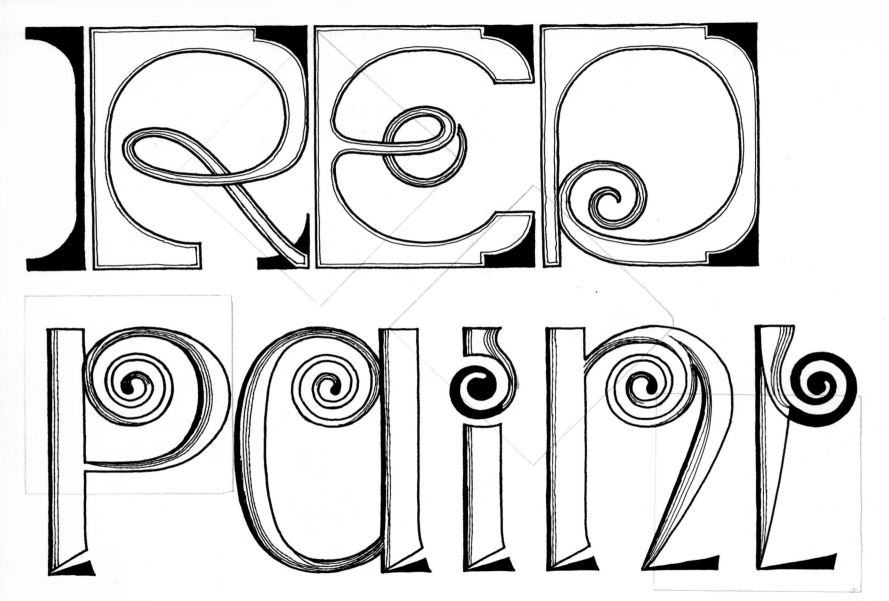

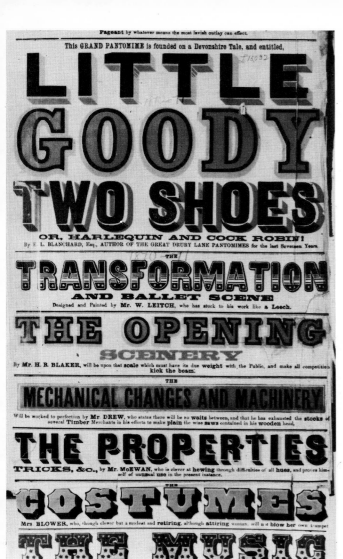

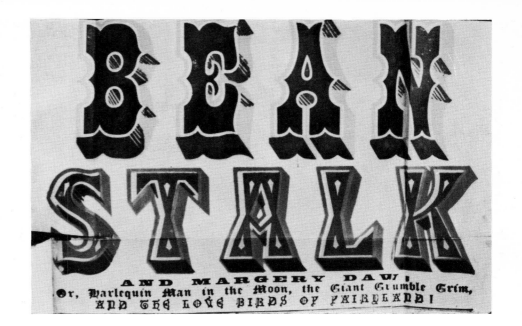

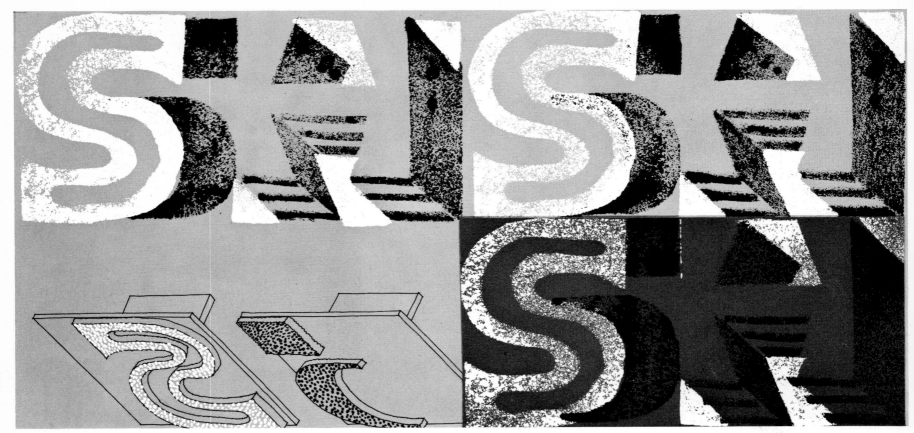

Theatre posters produced during the nineteenth century reflect the rumbustious quality of entertainment at that time.

The profusion and richness of colour on the posters was achieved by the use of separate colour blocks.

The essential requirement of a decorative letter containing one or more colours is the ease with which each block can be cut to fit in register,

either in proximity or with overlap.

A simple and effective method to print more than one colour is demonstrated by the repeated SH in black and white on grey card.

A block should be cut in reverse. I have prepared these simple variations from sheets of polythene foam shaped with a pair of scissors and then mounted on to a rectangle of card. The card

predetermines the spacing both between colours and between one letter and the next.

Ink or paint mixed to a suitable consistency is brushed on to a flat surface; the sheet foam pressed on to this will retain a sufficient quantity for transferring to paper or card by hand pressure. Six millimetres (about quarter inch) thick polythene foam will compress easily without squabbing and with a little practice will present a sharp imprint.

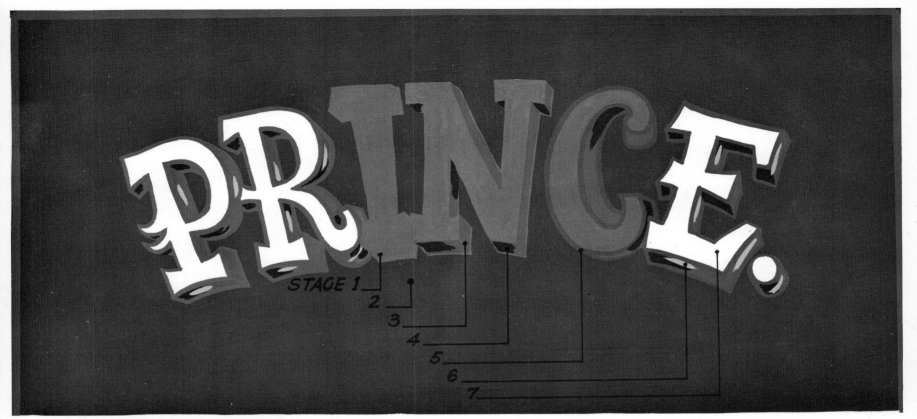

STAGE 1

2

3

4

5

6

7

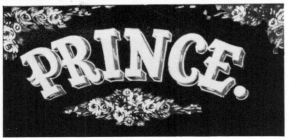

The quiet, unhurried canal allowed time for the decoration of everything on a barge.

The combination of folk art, legend and geometric decoration was always skilfully executed and rich in pattern. The registered names reveal a direct and progressive sign writing technique.

The visual differences between the less restrained PRINCE and the more carefully organised IPOMOEA (page 20) are very marked. The OE diphthong is well designed.

In the experimental letters JGO! and BARGE (page 19) the shadow character and letter outline are developed with a free use of poster paint and water colour. The letters OE, AE, FL, FF (page 21) and the method of painting them closely resemble that shown in IPOMOEA.

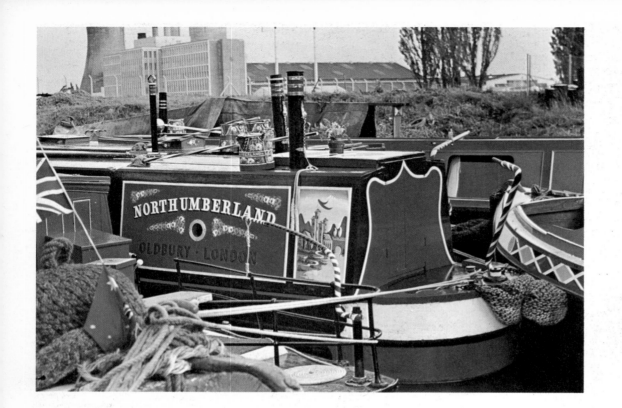

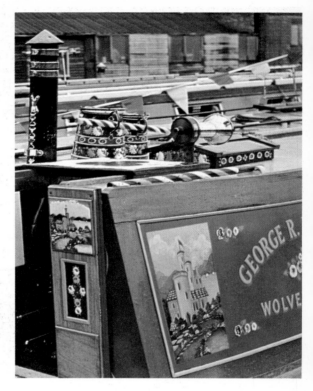

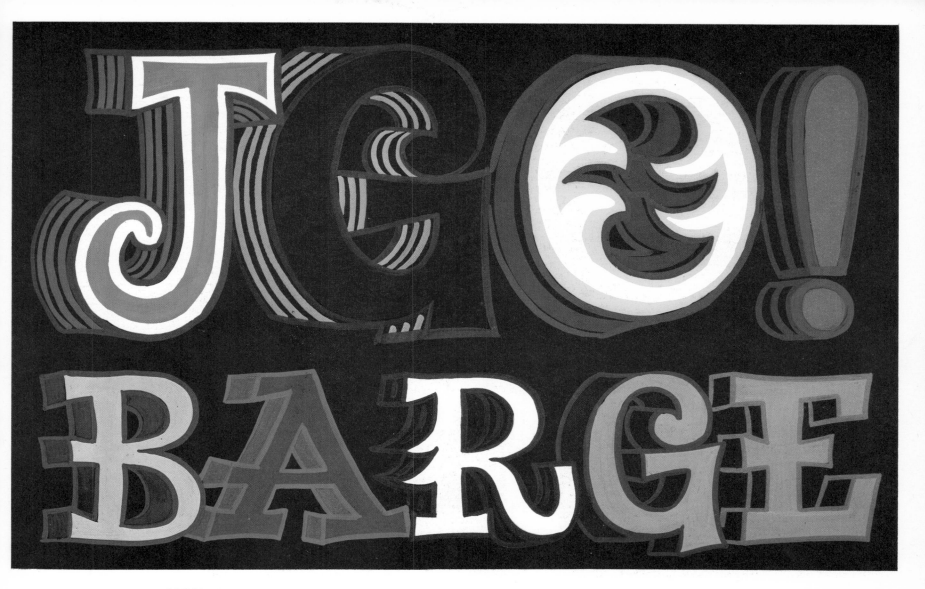

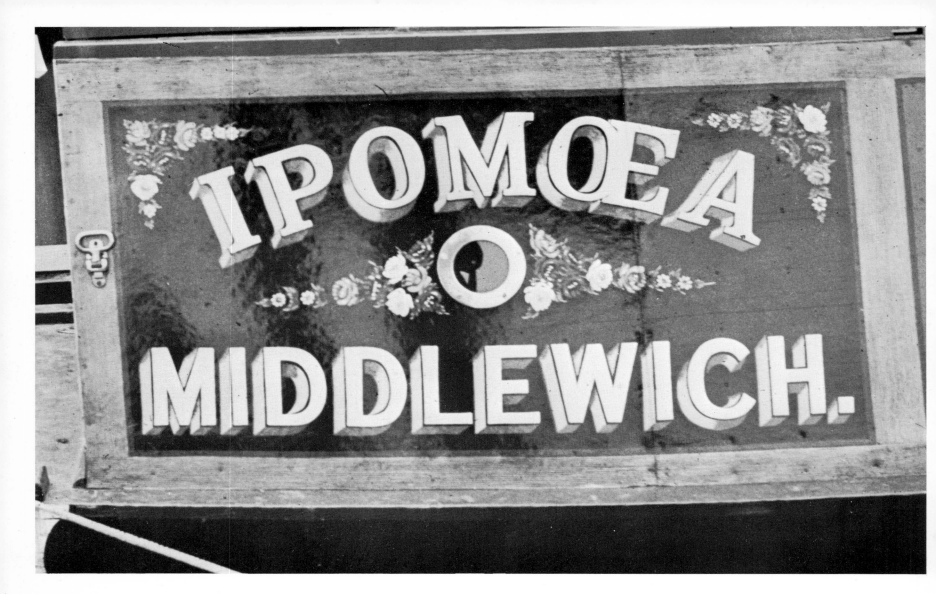

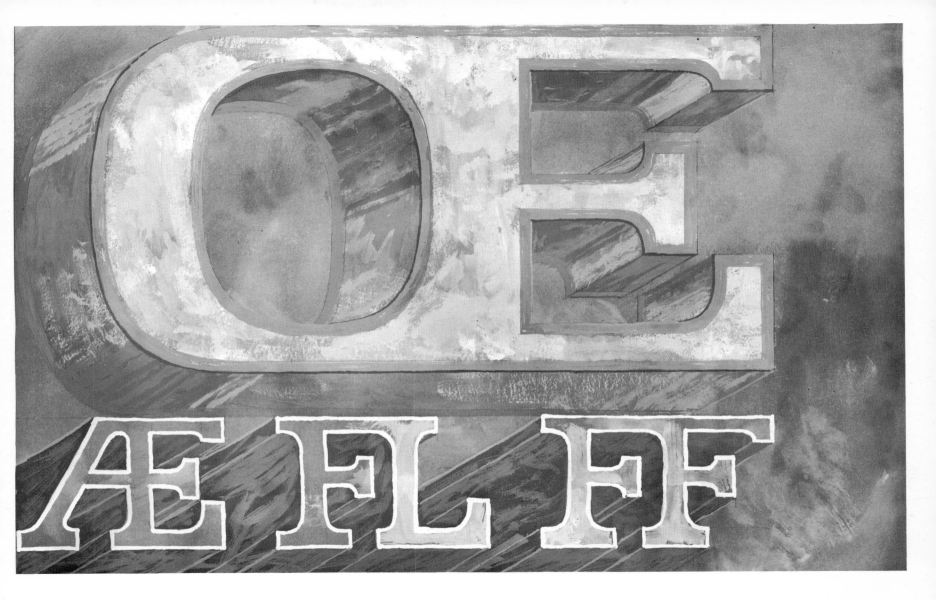

21

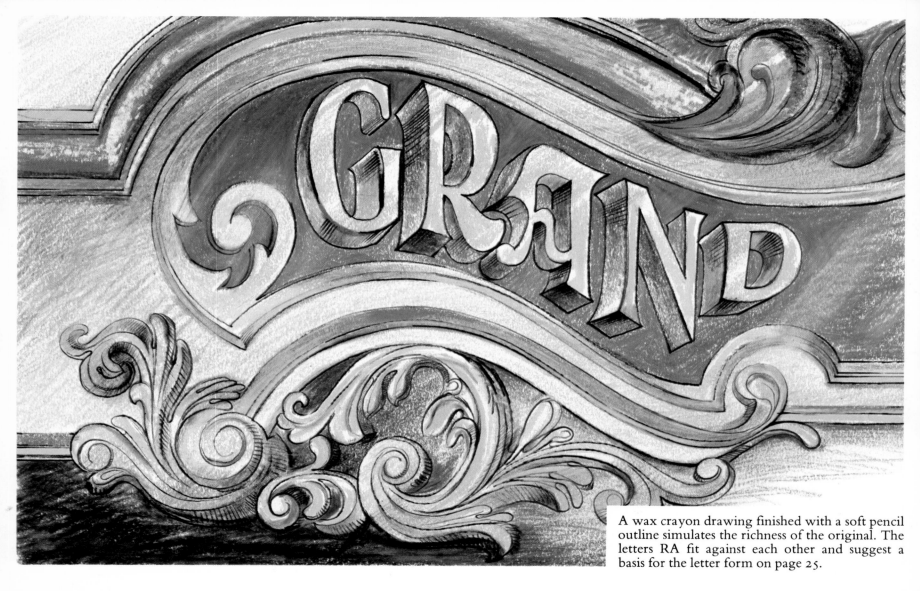

A wax crayon drawing finished with a soft pencil outline simulates the richness of the original. The letters RA fit against each other and suggest a basis for the letter form on page 25.

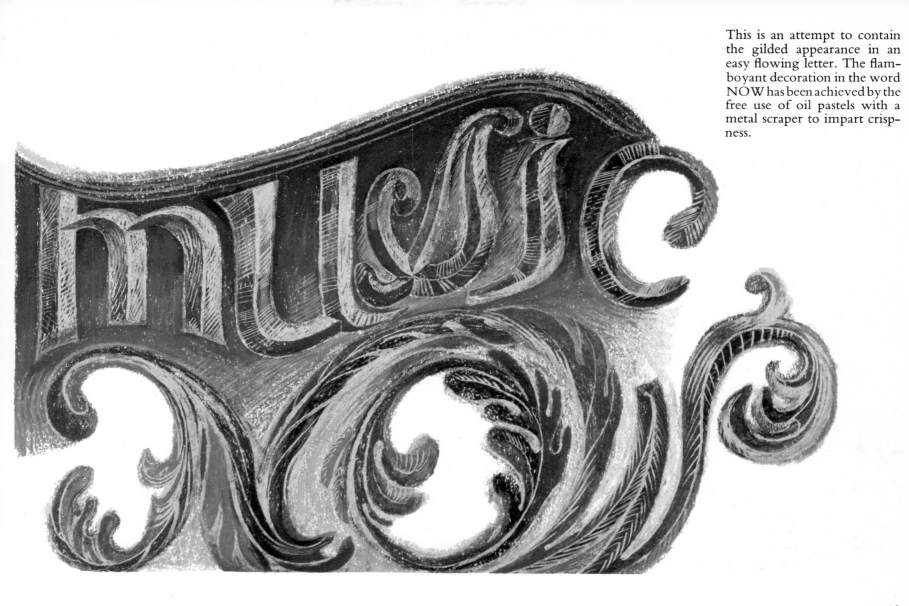

This is an attempt to contain the gilded appearance in an easy flowing letter. The flamboyant decoration in the word NOW has been achieved by the free use of oil pastels with a metal scraper to impart crispness.

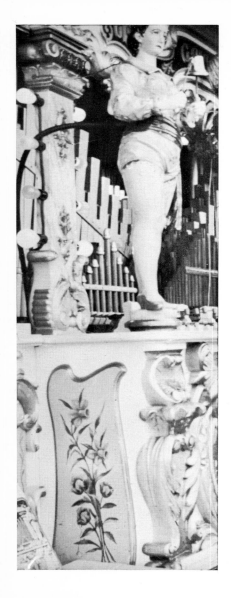

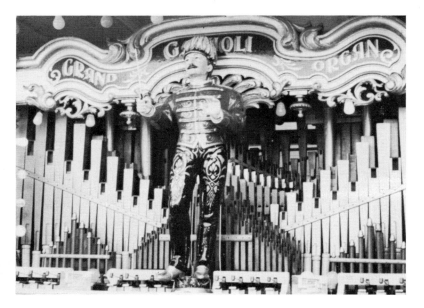

This grand organ is a wonderful example of showmanship, with its rollicking rococo decoration and the beautifully carved and painted figures, animated to keep time with the music.

The animals are contrived to fit the scrolls, and the lettering is an integral part of the decoration. The well-balanced colour, with gold and blue predominating, conveys something of a party atmosphere.

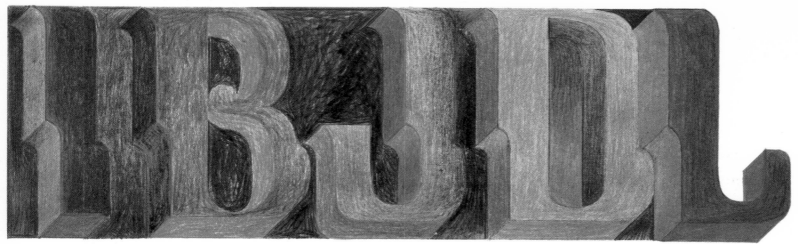

These letters were suggested by the RA of GRAND on page 22 and were developed by overlapping the R support stroke with the decorative element in the A up stroke. The simplification of this accident and the blob on the A are incorporated in the letter form on this page.

A fairly wide range of coloured pencils was used with care. The placing of colours that were either complementary or contrasting was deliberate.

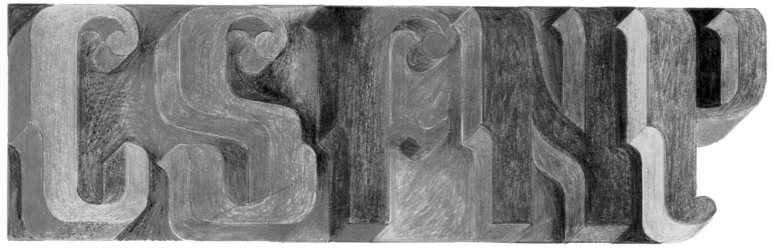

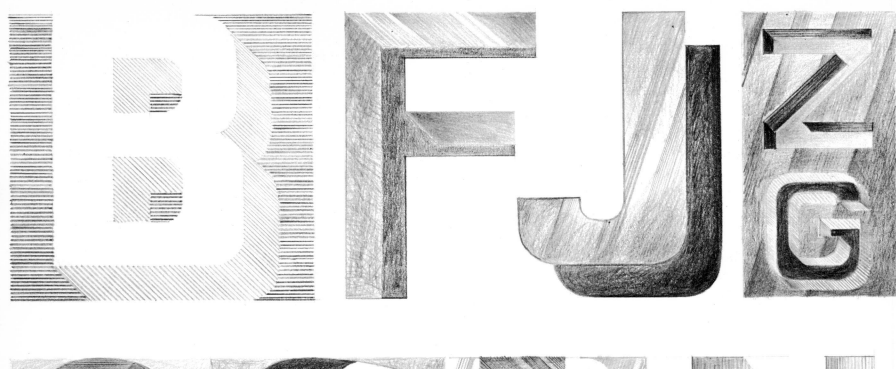
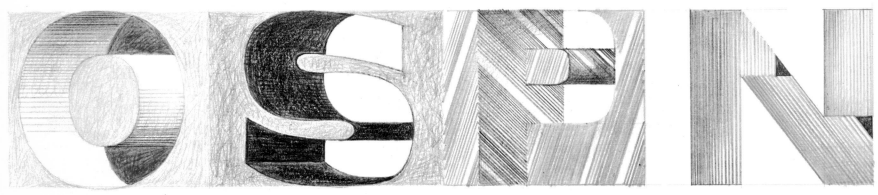

26

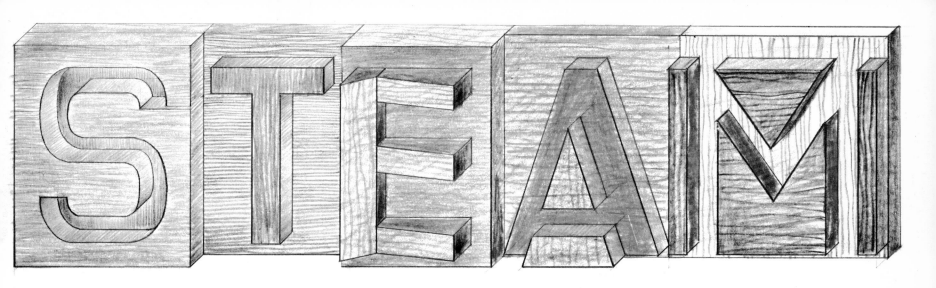

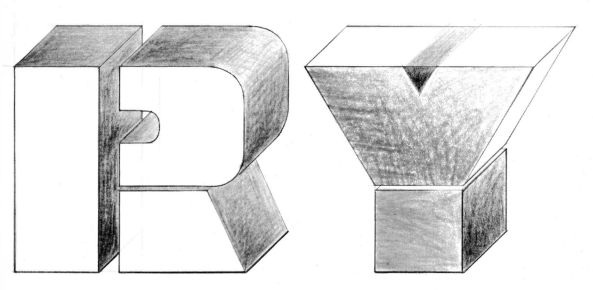

A development from the lettering off the steam tractor (page 31) is possible by using painted wood blocks and slabs. These could be shaped by a few simple tools to be found in most school workshops. It is advisable to complete the staining or colouring of the separate parts before gluing them together with a strong adhesive.

27

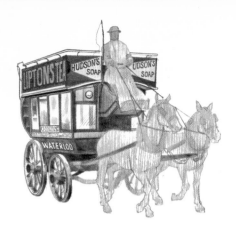

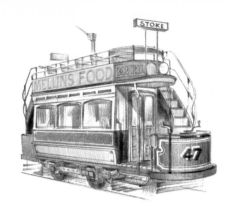

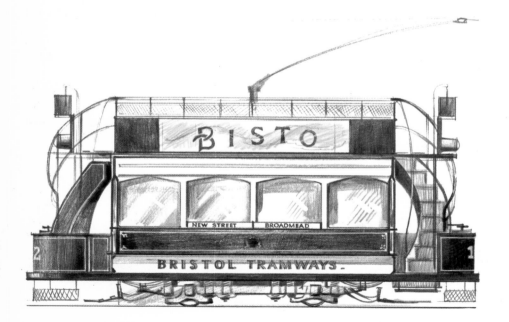

The letter forms on this tramcar are so well done that they are legible whether the car is travelling or stationary. The high standard of legibility is achieved in three ways. The letters themselves are simple, concise and solid; the shadows on the letters are restrained and graduated; and subtle colours have been used for the background, allowing the letters to stand out clearly.

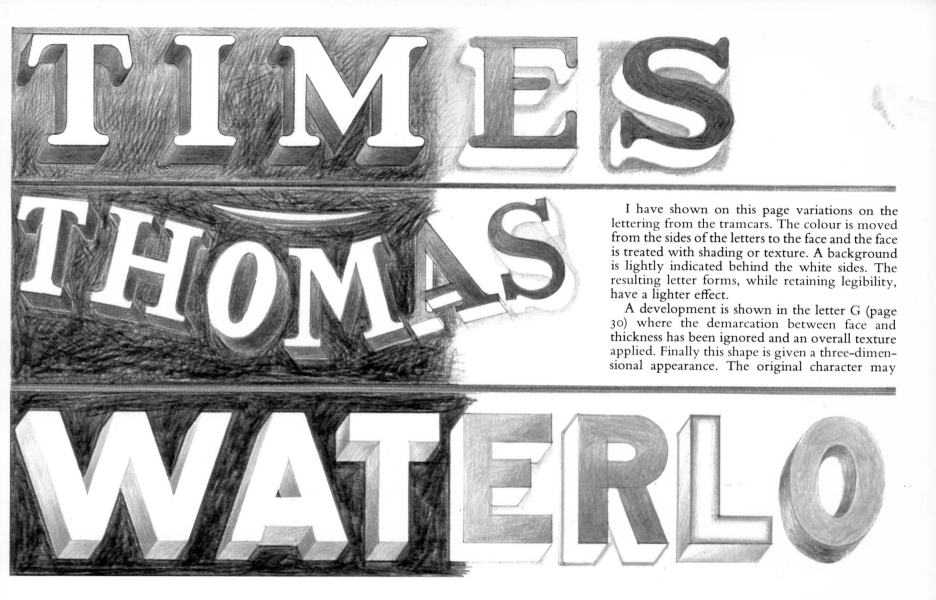

I have shown on this page variations on the lettering from the tramcars. The colour is moved from the sides of the letters to the face and the face is treated with shading or texture. A background is lightly indicated behind the white sides. The resulting letter forms, while retaining legibility, have a lighter effect.

A development is shown in the letter G (page 30) where the demarcation between face and thickness has been ignored and an overall texture applied. Finally this shape is given a three-dimensional appearance. The original character may

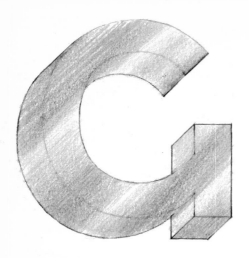

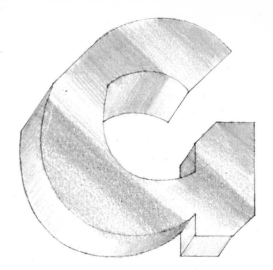

still be noticed but the letter form is different.

Coloured pencils were used with various infill techniques, cross hatching, random scribbling and

regimented gradation, overlapping one colour with another.

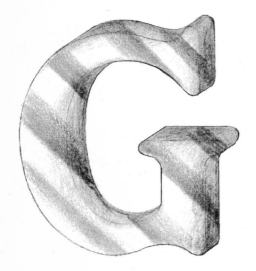

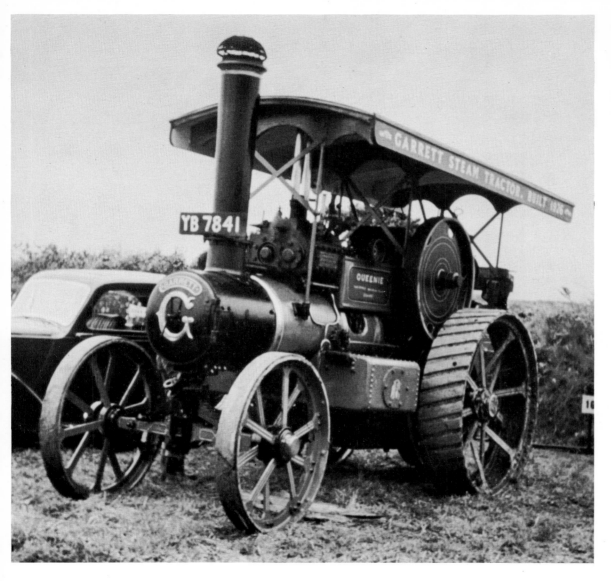

Everything about the steam tractor 'family' suggests weight, power, and reliability.

The highly polished cast metal name-plates and trade symbols, carefully finished off with striking enamels, are in keeping with its robust image.

I have taken the simple block letters from the engineer's name plate. I have endeavoured to re-create a three-dimensional image using coloured pencils with a limited range of reds, greens, blue-greens and yellows. This is done by changing the juxtaposition and colour of recessed or projecting forms. The simulated effect of the polished surface is essential to the appearance of this letter form. See also the lettering on page 27.

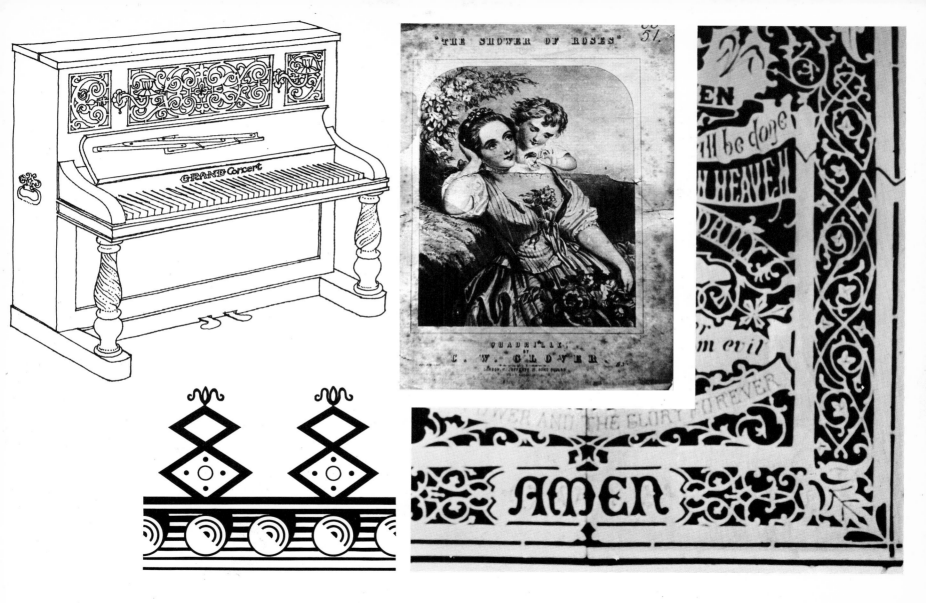

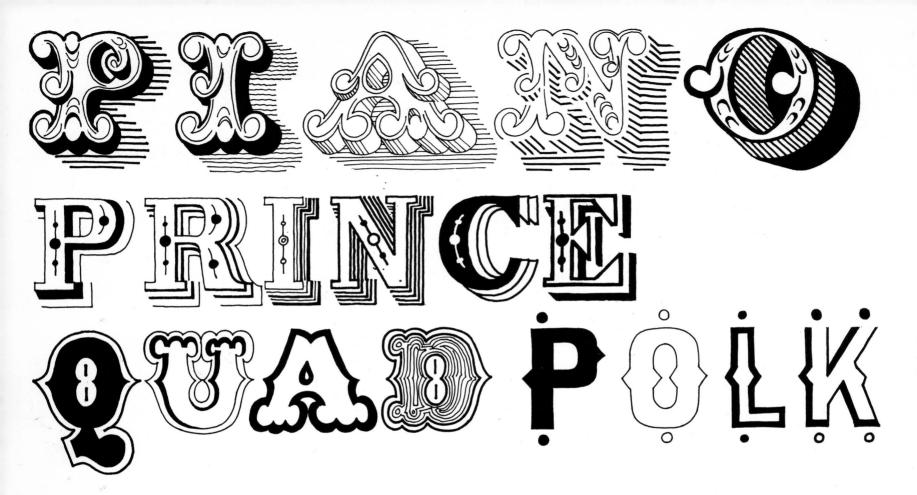

From our standpoint the piano and the music sheet are inseparable, as both display decoration that is rich and romantic. The carved and fretted panels, the collapsible music stand and the hinged candle sconces have their counterpart in the freely decorated letter forms and coloured lithographed illustrations on the music sheet covers.

These sample words were taken from different music sheets but only the first letter of each word is a replica of the original. The remainder are given a treatment that is in part characteristic of the original letter. It follows that each letter could be the basis for a full alphabet.

For the purpose of this book these letters were enlarged from the original by three or four times.

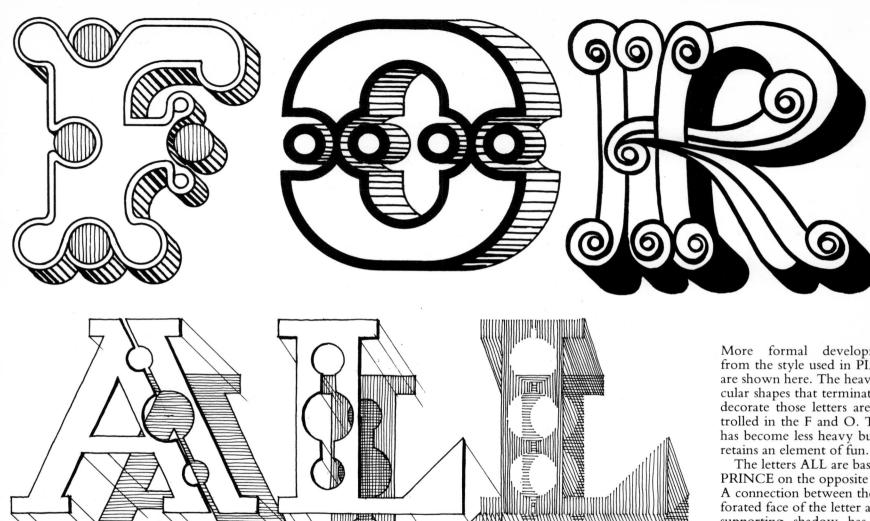

More formal developments from the style used in PIANO are shown here. The heavy circular shapes that terminate and decorate those letters are controlled in the F and O. The R has become less heavy but still retains an element of fun.

The letters ALL are based on PRINCE on the opposite page. A connection between the perforated face of the letter and its supporting shadow has been treated with some licence! These letters were drawn with brush and pen.

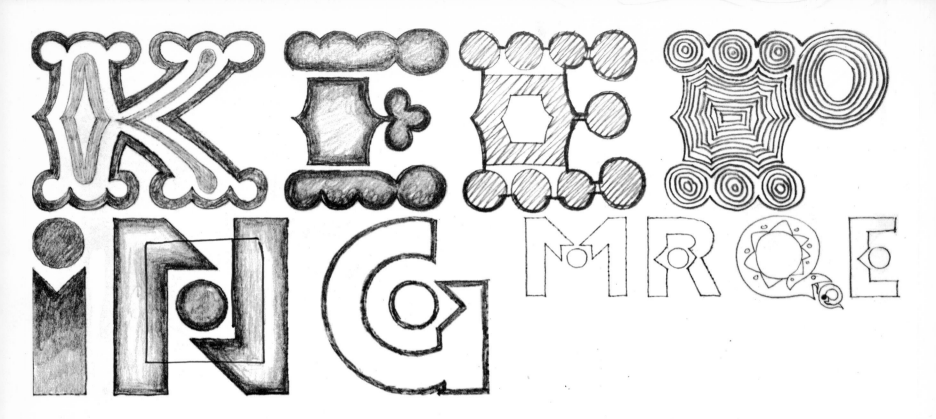

The freely drawn pencil letters on this page are developments of the abbreviated words QUAD-RILLE and POLKA.

KEEP applies combinations of four different shapes to letter construction and each letter retains its legibility. ING and MRQE owe their form to a reversal of shapes taken from the P in POLKA. The dots are now included in the letter form and the angular projections become angular indentations.

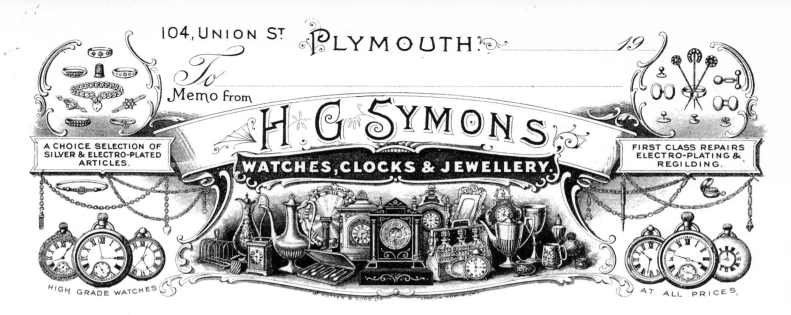

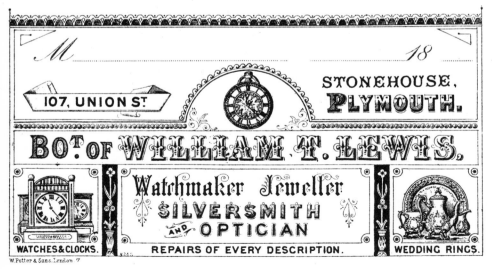

The two bill headings are typical of a decorative arrangement illustrating either a service or goods for sale.

The suggestion that any transaction is made in the name of business is softened by the extravagance of these pictures. They date from the late nineteenth and early twentieth century.

The basis for development on this theme is the essentially linear quality of the WILLIAM T. LEWIS heading. This is presented as a decorative banner and each individual part has its own framework pierced in the corners.

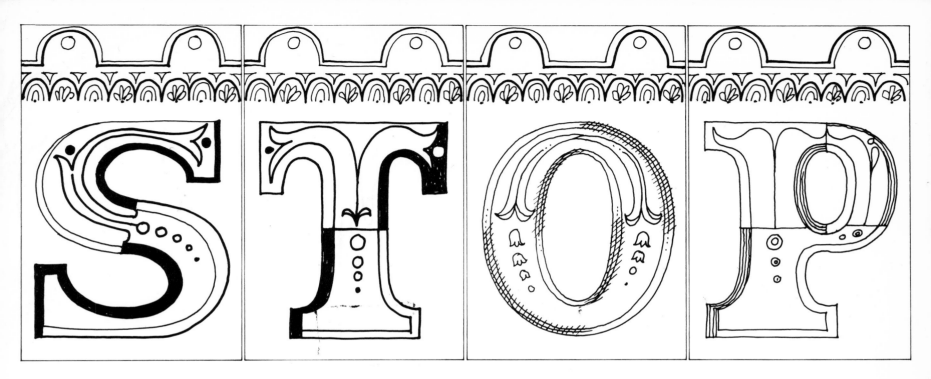

The decorative separation of one part from another can be used both to divide each letter from its neighbour and also to allow some method of positioning to be included in the arrangement.

The letters are simplified and the essential character of repeated lines of varying thickness and interval is shown on page 38.

An effect abstracted from the upper ends of the WILLIAM T. LEWIS letters is shown in STOP. The upper parts of the letters are enclosed and the split decoration becomes a simple foliate pattern.

These examples were drawn freehand with pen and ink.

39

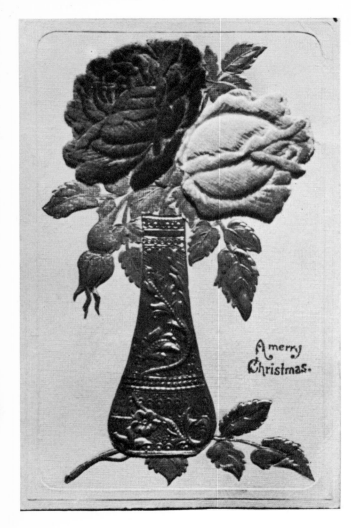

A merry Christmas.

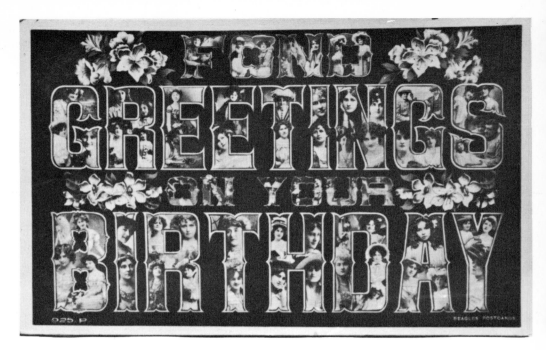

FOND GREETINGS ON YOUR BIRTHDAY

I have always been fascinated by greetings and commemorative cards. The best examples will always have elements of surprise, enjoyment and flair. For these qualities it is very difficult to surpass the French made greetings cards which poured into this country from our soldiers during the First World War. These were decorated with a combination of embossing and lace, and carried a short embroidered message of affection. I was enchanted by their gay appearance at a time of general austerity and drabness.

The two postcards illustrated here are dated about 1908 and are decorated in a way that provides a rich and varied support to the message.

To recreate the character I have used materials that are easily obtainable.

For the word DECOR I have used patterns cut from wallpapers. For ATIVE I have used selected photographs cut from newspaper supplements stuck on to card, lined with white paint. Cut and folded paper doilies produce ABCDEM on page 44.

The church-like funeral card provides the basis for a decorative cut and folded card structure on page 43. This improbable façade is presented with stick-on labels, stars, legal seals and gummed reinforcements. The lettering is cut from folded gummed paper. Finally I have drawn some architectural detail with a pen.

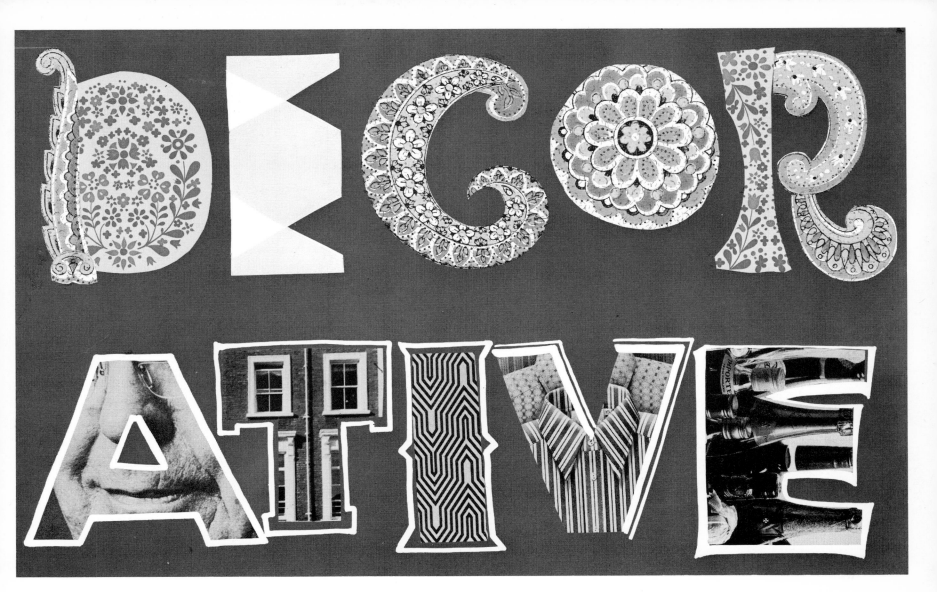

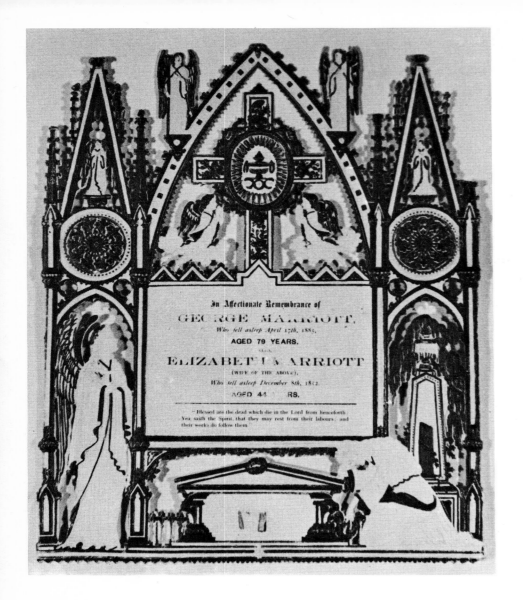

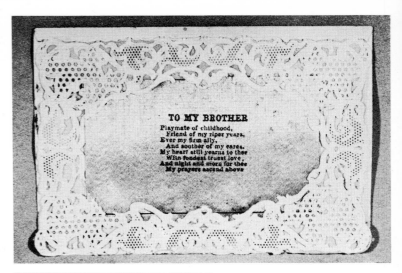

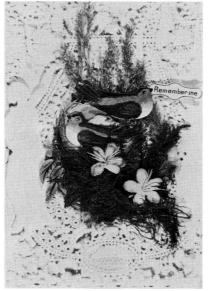

Remember me

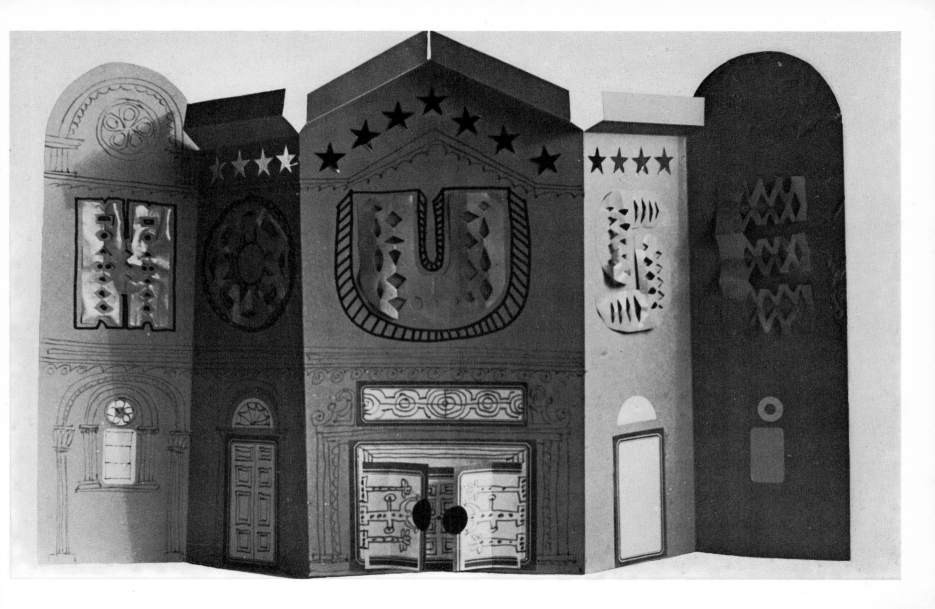

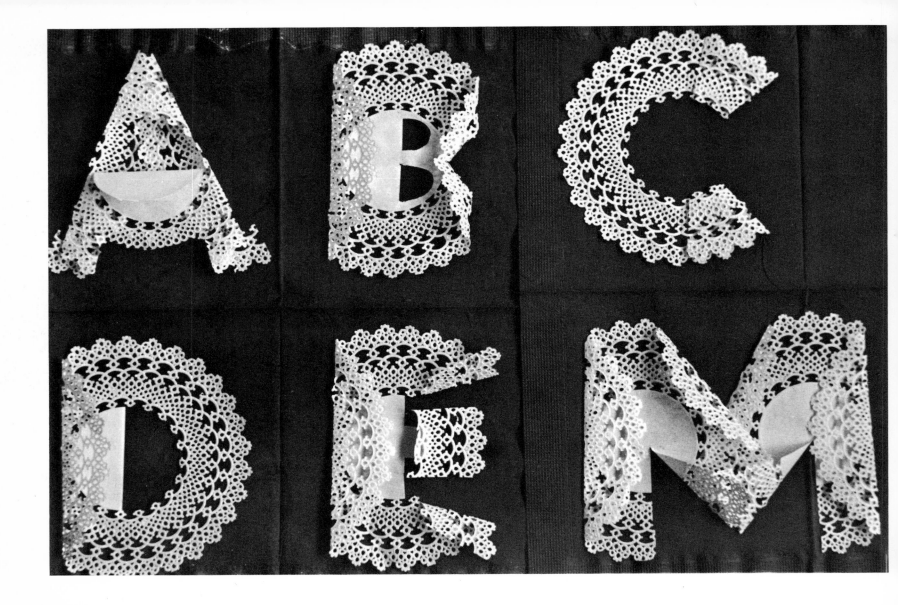

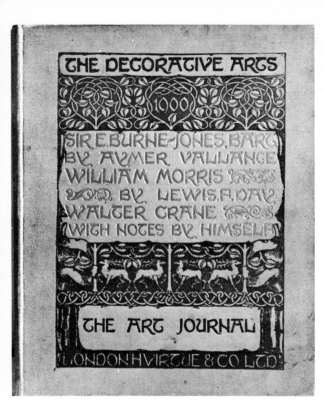

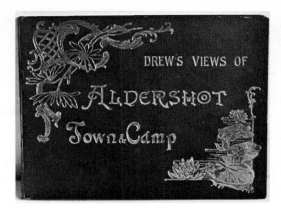

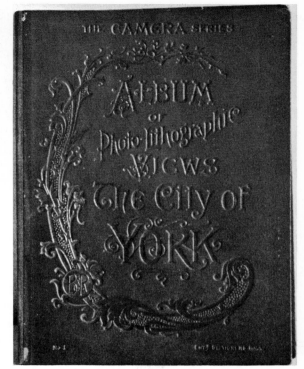

Victorian and Edwardian books provide a fascinating source of unfamiliar letter shapes, particularly from the covers and initial letters. Here are four good examples.

Even mass produced books were bound in linen or with boards covered in textured papers. Decorative patterns and titles were then blocked on to the book using gold leaf and variously coloured inks.

SIR E.BURNE

AVTLFWGJ

architectural

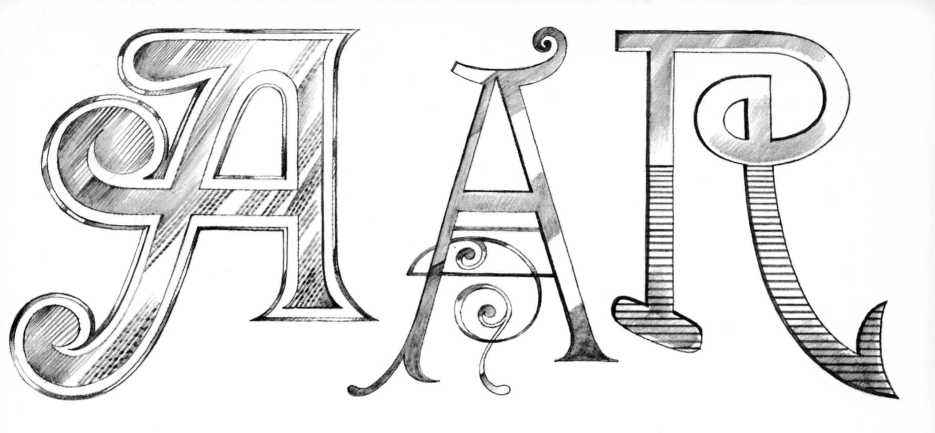

These are examples of letters that were gold blocked on a textured ground. I have tried to capture the sparkle of the gold in a variety of ways, using only a pencil on ordinary drawing paper.

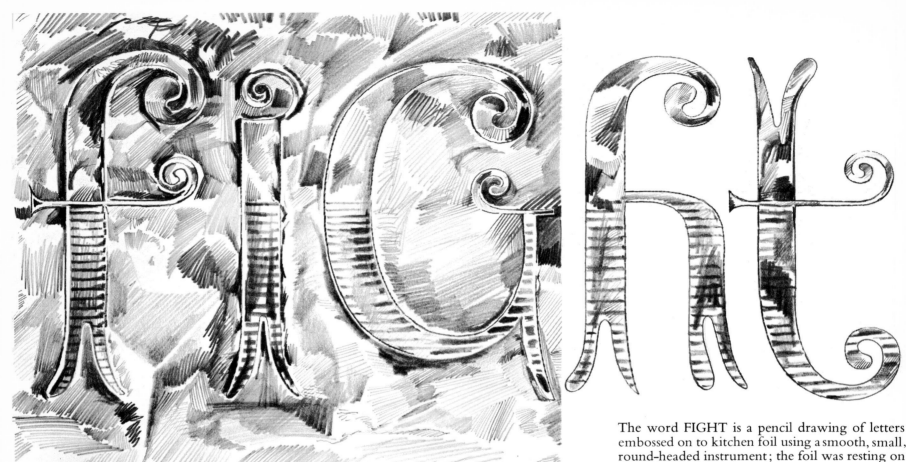

The word FIGHT is a pencil drawing of letters embossed on to kitchen foil using a smooth, small, round-headed instrument; the foil was resting on several newspapers to provide a cushion.

This may be considered an elaborate way to produce lettering, but the practice obtained by an objective drawing of crumpled foil is very valuable. Should the drawing be a failure there is always the embossed foil to show, and with suitable lighting this can look quite effective!

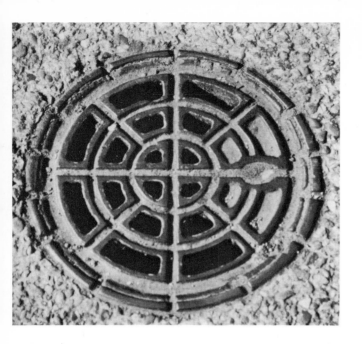

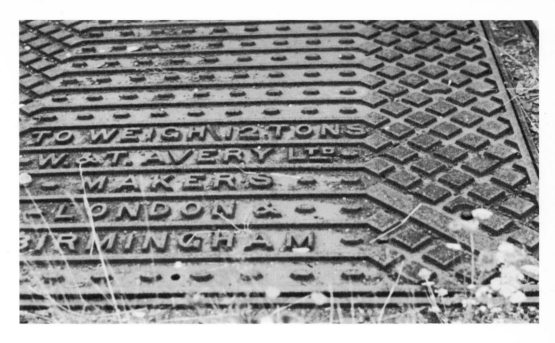

TO WEIGH 12 TONS W. & T. AVERY LTD MAKERS LONDON & BIRMINGHAM

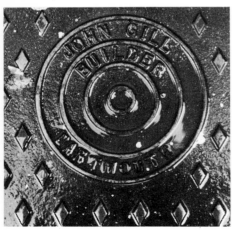

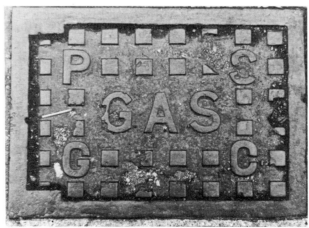

Most services are taken for granted and the covers giving access to them seldom receive more than a passing glance. It surprises me to find such a veriety of pattern and lettering on signs and the covers to manholes, stop taps, fire hydrants, electricity, gas and other services.

Pavement channels for example must be extremely tough, offer a non-slip surface and at the same time the lettering must be legible.

The simple decoration of squares, rectangles, lozenges, lines or concentric circles are satisfyingly solid. It is quite surprising how many variations can be found in the old and not so old streets of the average town.

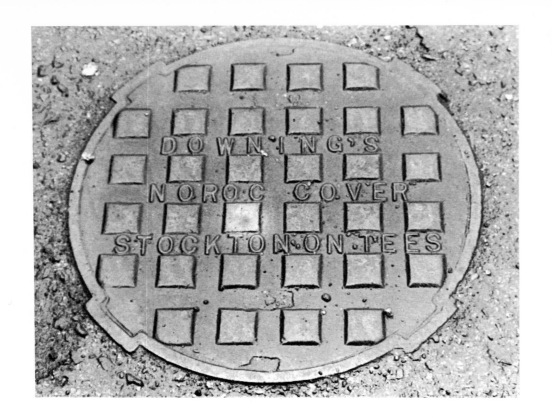

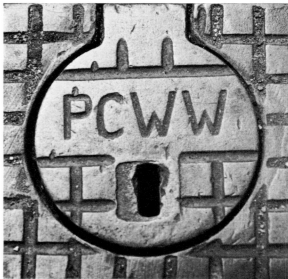

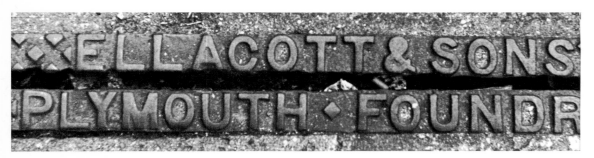

The letters EH and FG are an experiment using small pieces of card cut to predetermined sizes, then arranged, and finally glued down. The pattern of thinner lines was added to give some relief from the stark appearance of the letters.

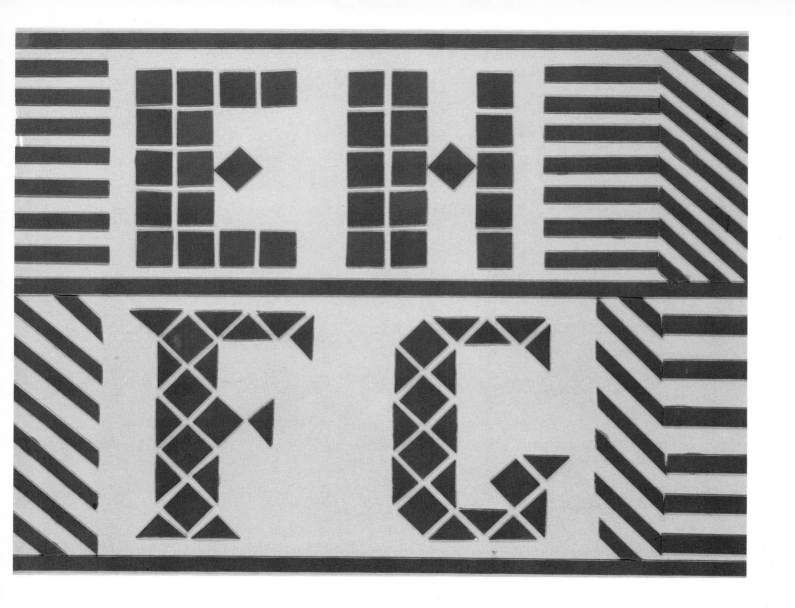

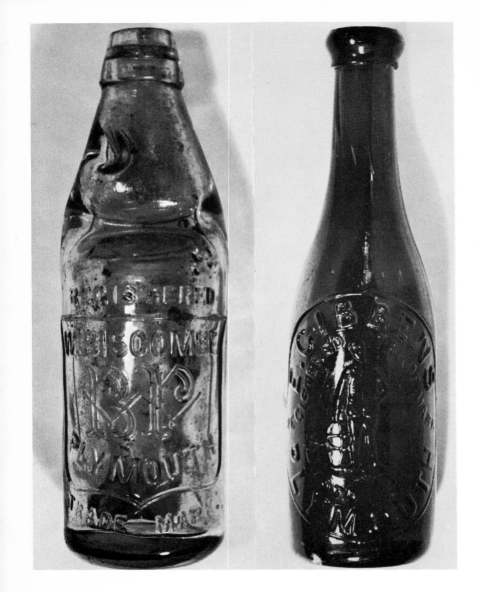

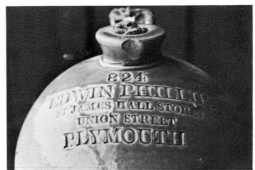

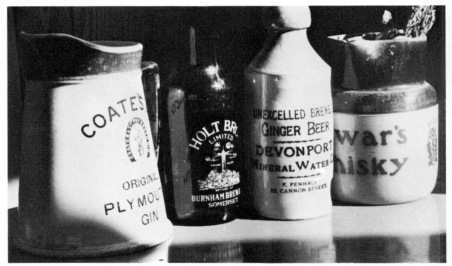

Old glass soda water bottles and ginger beer bottles made in stoneware are now collectors' items. That so many bottles could have disappeared almost without trace does surprise me, but I am certain that many were broken to release the glass marble – a coveted acquisition amongst small boys!

Letters are moulded on to glass and transferred on to stoneware. The lettering on these bottles is unpretentious and workmanlike and does not detract from the generous form of the bottles.

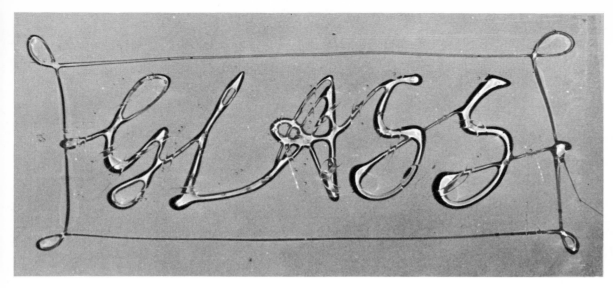

Lettering on glass can be simulated by using Bostik clear adhesive. Squeeze directly from the tube on to a clean sheet of glass, a bottle or jam jar. The squeezing can be manipulated to present a thick or thin line and to appear fast or slow in form. The glass sheet or jar should be as horizontal as possible and preferably placed on a white background to simplify working. When completely dry, ends of letters can be trimmed with a sharp blade. The result is remarkably like moulded glass letters.

Impressed letters that retain their form can be produced by imprinting or scraping into a layer of Polyfilla (with colour added) which is spread into a stiff paste. When dry the lettering or the background may be painted separately.

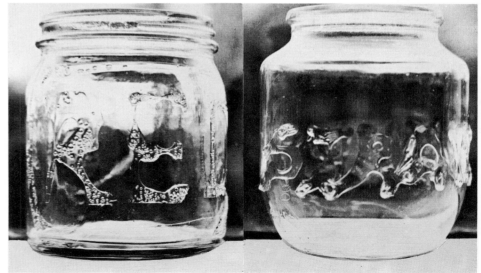

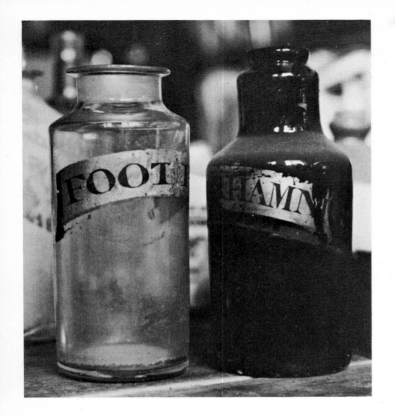

Before the era of pre-packed pharmaceutical products a visit to a chemist's shop was a real visual experience. There were rows of containers in clear or coloured glass, each carrying a name on a decorative gilded label and all neatly marshalled along shelves behind the counter. The rare chemicals were kept behind glass doors that were firmly locked.

Gold poster paint has been substituted here for the gold leaf. The paint will flow easily on a glass surface if a touch of detergent is used when mixing it. The gold paint is applied to one side of the glass sheet and the lettering to the other. The thickness of the glass will separate the lettering from the gold background, and with suitable lighting a shadow may be cast by the letters on to the gold.

The letters ASPRI are surrounded by black poster paint giving a suggested depth to the letter. The letters SALTS were cut from gummed paper squares and stuck to the glass, and appear to stand away from the gold background.

With the word LINCTUS a final development has been made by contrasting the dull and shiny surfaces of metal foil. This contrast is enhanced by crinkling the metal foil letters; it is better to crinkle the sheet before cutting the letters out. Then glue the letters down on to the smooth sheet of metal foil.

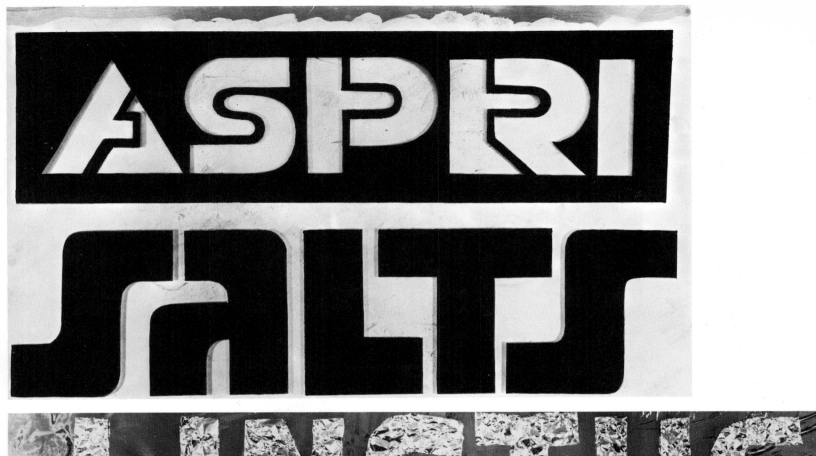

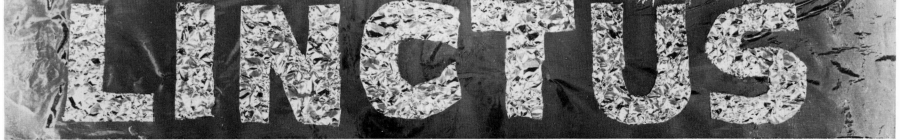

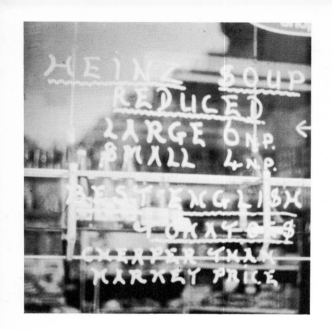

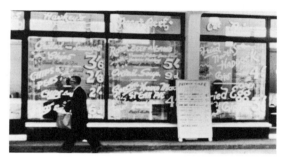

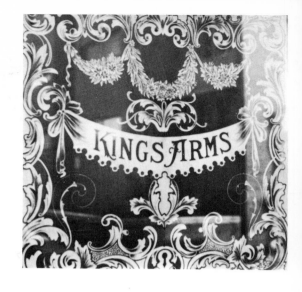

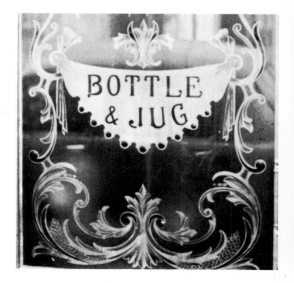

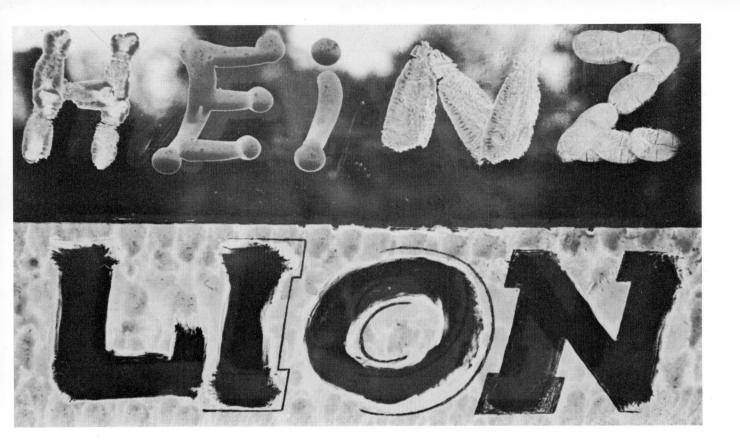

Random writing on shop windows for the purpose of stimulating trade can be compelling, informative, and even legible! The normal practice is to write directly on to the glass from the front using pigment that is easily removed (i.e. whitening or a soluble water paint). The fingers, knuckles, and the heel of the hand can produce both legible and exciting letter forms as shown in HEINZ. A brush or aerosol spray is more usual!

Sand blasted decorative glass can be found in the windows and door panels of many old public houses and hotels. The two photographs, "King's Arms" and "Bottle and Jug", are good examples. This effect can be imitated by rubbing a ground of white poster paint on to glass with damp cotton wool and scratching lines in the paint with a pointed metal instrument. This has been done for LION.

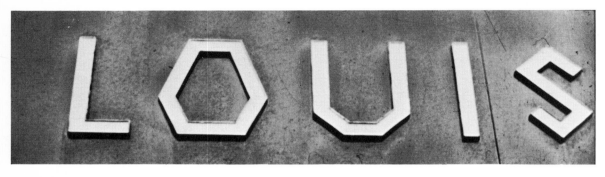

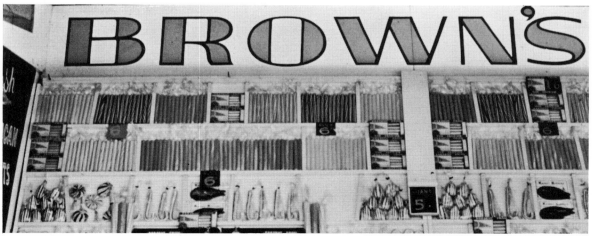

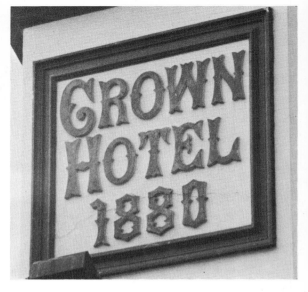

The examples shown here were produced in different materials at very different times. LOUIS FORD was done in stainless steel and enamel inlay about 1930; BROWNS in oil paint on wood about 1960; and CROWN HOTEL in cement in 1880.

Suggested developments are based both on shapes of characters and on materials. The sharp angularity of ER, done with rolled and cut paper, was suggested by LOUIS FORD. The use of sweets for GQKT was suggested by the confectionery in BROWNS. Finally for 234 strips of paper were stuck together with gummed paper, folded, curved and glued to a sheet of card; the figures were suggested by BROWNS.

Any three-dimensional development, whatever the material used, can be observed and provide the starting point for a new drawing of the letter.

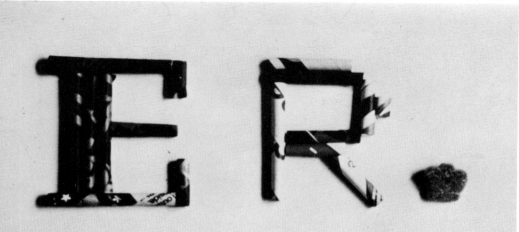

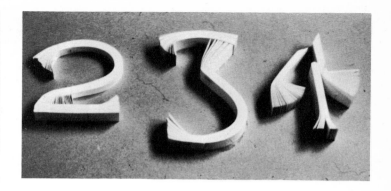

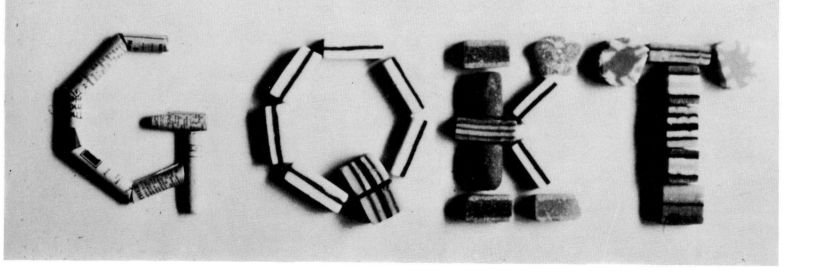

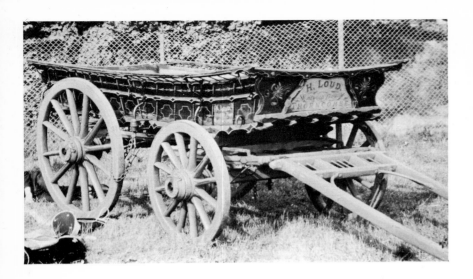
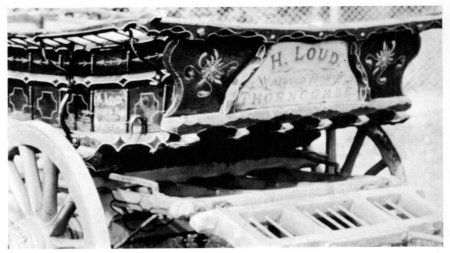

Agricultural shows often have the added attraction of old farm implements and wagons. I saw this wagon at a show in Devon; its finest features were very delicate lining-in and fine brush decoration. This is an example of lettering completely in character with the construction it is drawn on. The lettering is gracefully flanked by brush whorls suggestive of a honeysuckle motif. The whorls cleverly terminate at two points over a bolt head.

Using poster paint and brush I have used the various lining-in and brush patterns to decorate simple letter shapes based on H. LOUD.

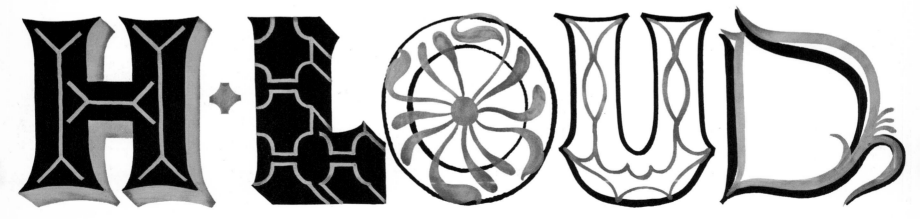

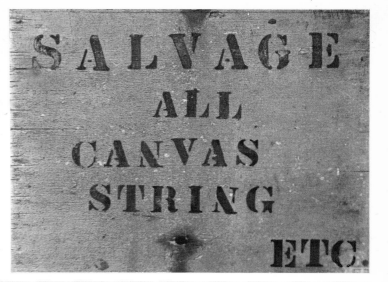

SALVAGE

ALL

CANVAS

STRING

ETC.

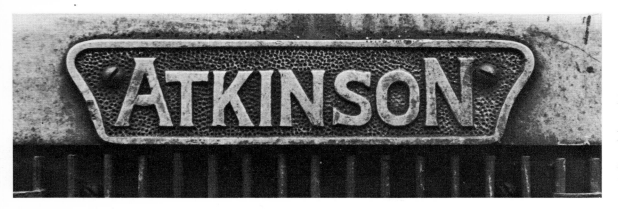

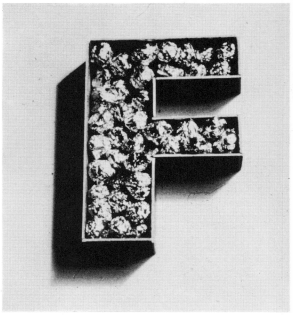

The examples in this section are from different
origins, but all are related to rail or road transport.
With the exception of a stencilled salvage notice
the remaining letter forms are cast in metals and
have different textural features.

By a choice of simple materials I have suggested
a method of adaptation that is inexpensive and
striking.

F is assembled from cardboard strips glued to a

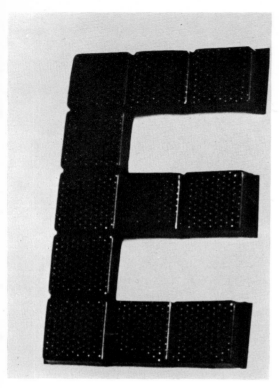

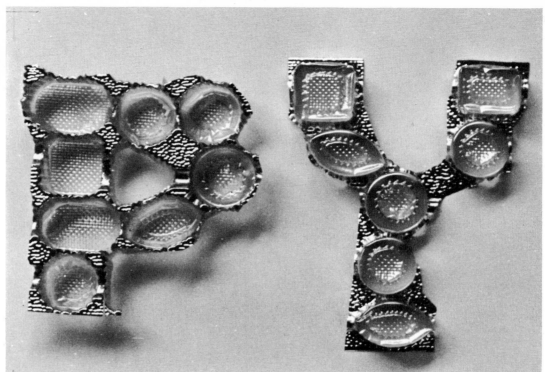

base; the inside is filled with metallic foil rolled into small balls and fixed to each other with a spot of adhesive.

A and T are made from crinkled and plaited metallic foil.

E, P and Y are vacuum packs from chocolate and fondant boxes adapted to letter form shape by selective cutting. The forms are very simple and effective.

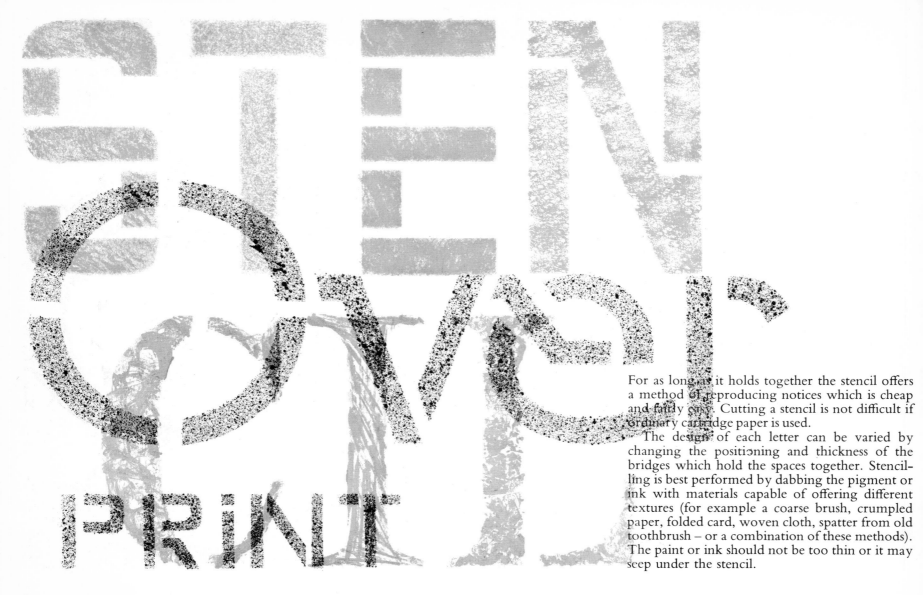

STENCIL PRINT

For as long as it holds together the stencil offers a method of reproducing notices which is cheap and fairly easy. Cutting a stencil is not difficult if ordinary cartridge paper is used.

The design of each letter can be varied by changing the positioning and thickness of the bridges which hold the spaces together. Stencilling is best performed by dabbing the pigment or ink with materials capable of offering different textures (for example a coarse brush, crumpled paper, folded card, woven cloth, spatter from old toothbrush – or a combination of these methods). The paint or ink should not be too thin or it may seep under the stencil.

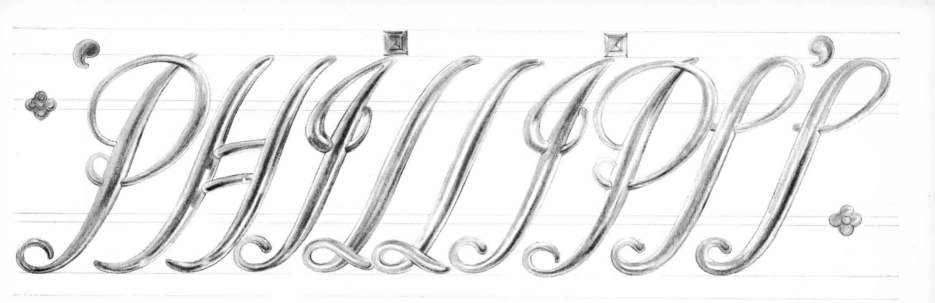

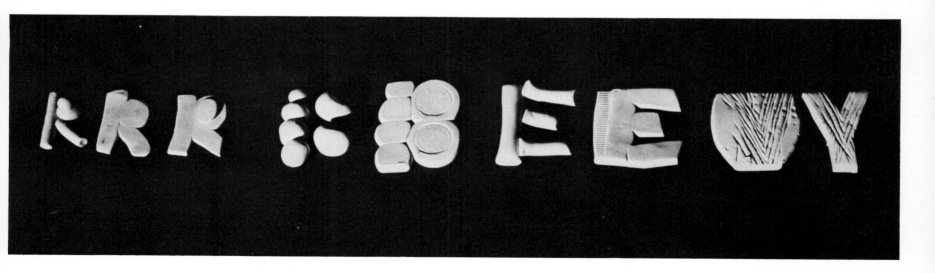

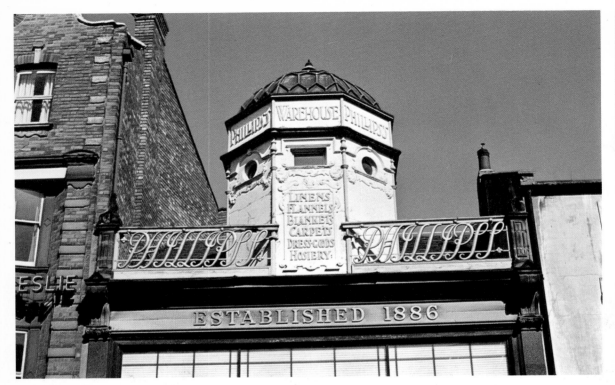

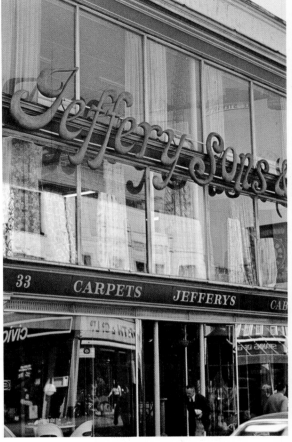

These enlargements of Victorian penmanship impart an aura of respectability and importance to the buildings they decorate. Made with wood, the letters are firmly secured to the unobtrusive metal supporting grid and carefully finished in gold leaf.

The lettering *Phillips's* flashes in the sunlight whilst *Jeffery Sons and Company* lends a sombre quality of light to a north facing façade. The letters in both are beautifully rounded in form and indicate the difference in legibility between a regimented capital letter and an equally regimented lower case letter.

I have shown two developments from these. The first is drawn with coloured pencils and using shadow and light to show the bright and discoloured gilding on a solid letter shape.

The second uses plasticine rolled into strips and balls, placed to approximate a letter shape, and then flattened. Occasionally texture has been added by pressing various objects into the surface.

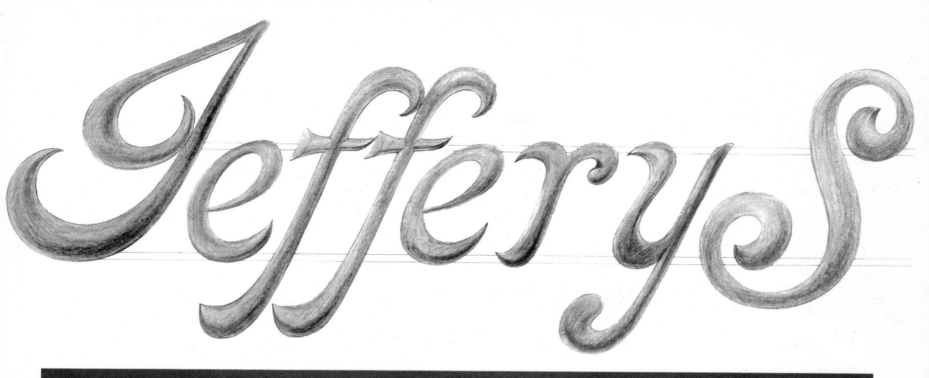

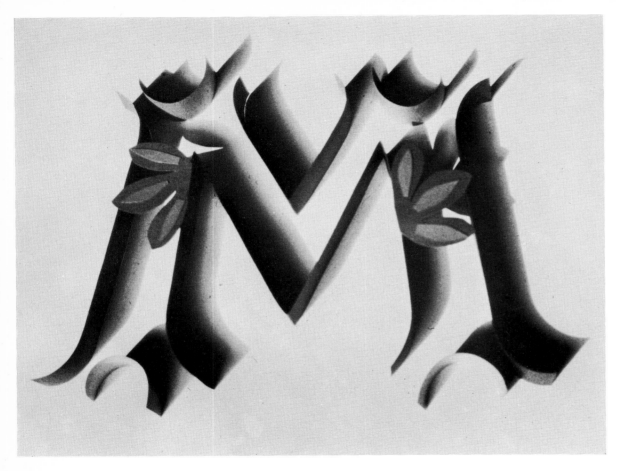

The three-dimensional coloured form can be effectively presented by using coloured paper strips, folded and curved and then glued standing on edge to a white cardboard ground. Leaf decoration is finally applied to bridge the letter's width. The ends of the forms are left completely open. This is a simple construction which is visually effective from every angle.

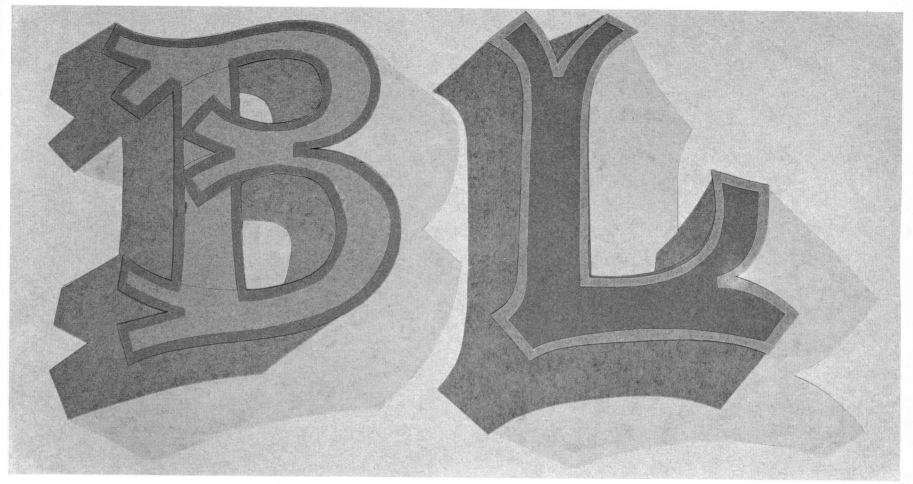

The letters BL have exaggerated split ends and were cut from coloured paper and glued together on to a coloured paper background. These shapes can be built up as follows:—

(1) Cut out and glue down the shadow which extends under the letter.

(2) Cut out and glue down the letter thickness which can extend under the face of the letter.

(3) Cut out and glue down the face of the letter.

(4) Cut out and glue down the letter edging.

In this sequence any irregularities can be hidden by successive paper layers until the last part is applied. It follows that the last layer must be carefully cut and placed.

69

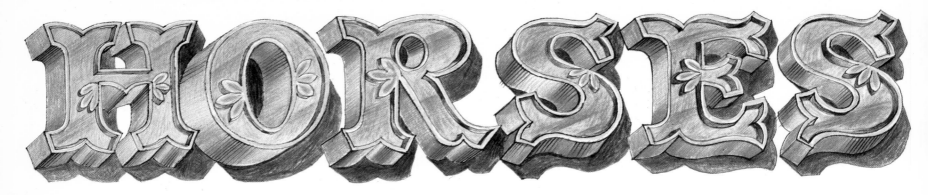

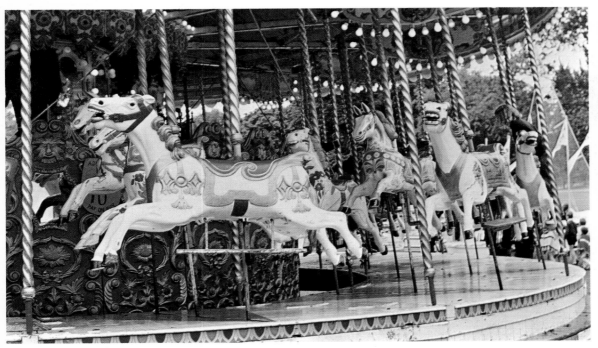

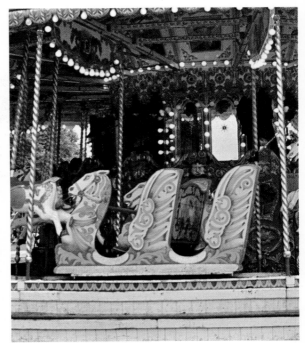

The gallopers' roundabout has great attraction. The up-and-down progression of decorated horses, the movement in time to electric organ music, the polished brass, brightly coloured lights and richly decorated lettering combine to make it one of the greatest audio-visual pleasures the fairground can offer.

I have taken the word HORSES (page 70) and presented this in a traditional manner. It is drawn with coloured pencils to show both the careful gradations on the letter thickness and also the shape of the shadow, which falls in the opposite direction to the letter. Note the important decorative characteristics: the split end forms and the three-leaved shape in yellow.

The freely drawn pastel letters SR have a three-leaved shape substituted for the split end. The letter thickness is splayed out from the face and no shadow is shown.

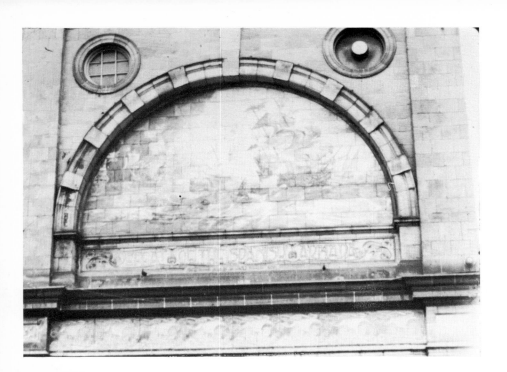

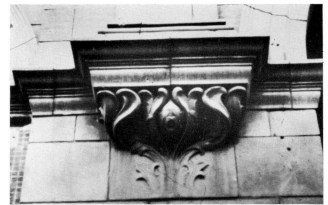

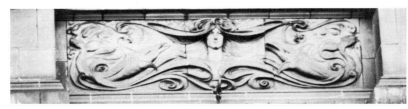

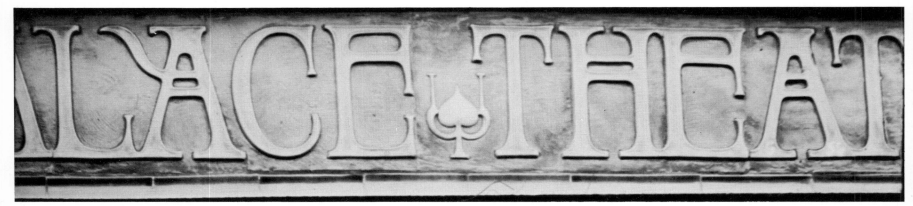

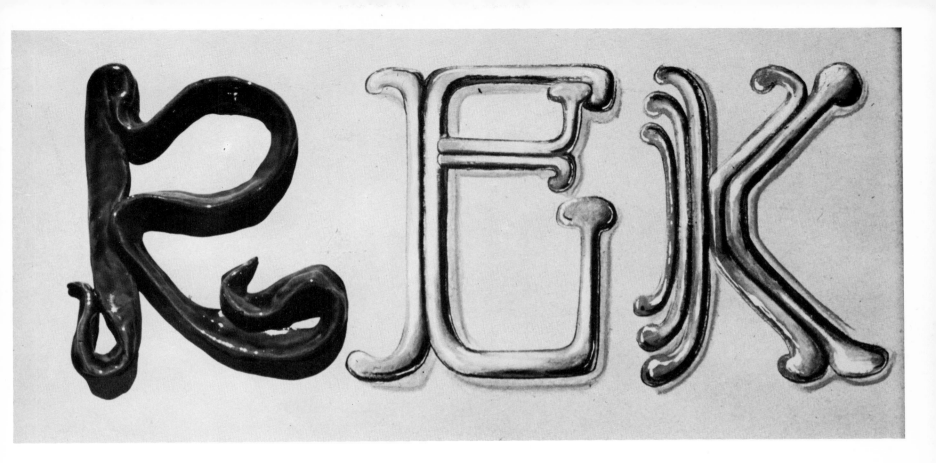

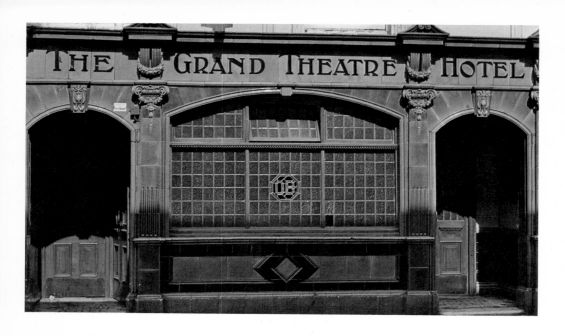

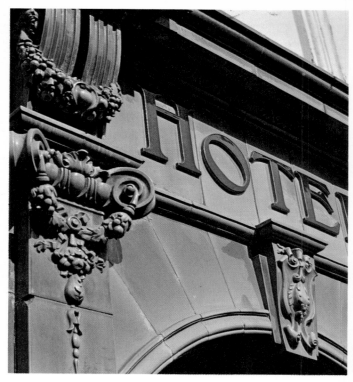

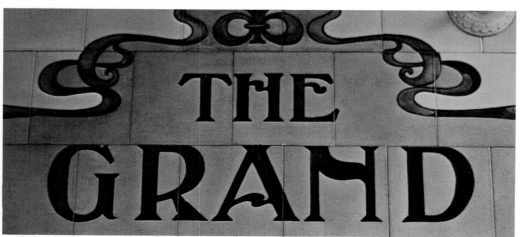

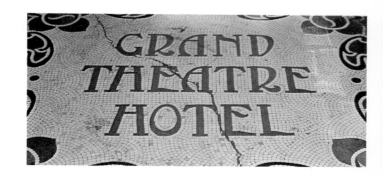

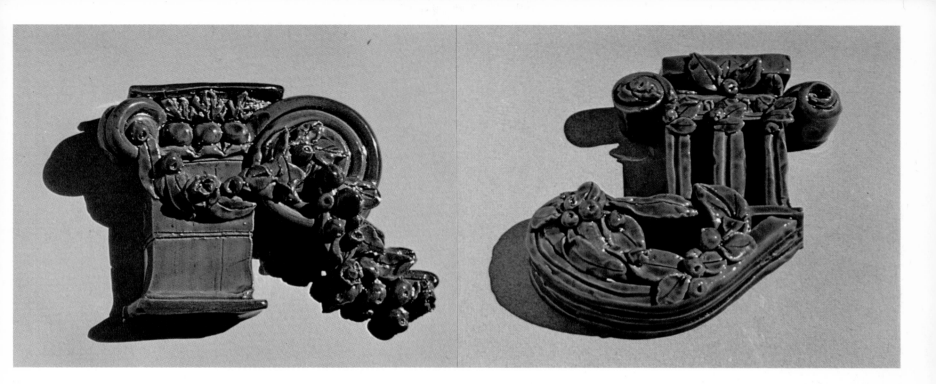

The following examples of lettering are from the Palace Theatre and the Grand Theatre Hotel in Union Street, Plymouth. As you might expect, both are rich in decoration.

The Palace Theatre is a highly ornate structure which is covered in very beautiful faience. The principal decorations are huge replicas of paintings featuring the defeat of the Spanish Armada. Numerous sailing vessels decorate a frieze and the corbels growing from the façade are fine examples of art nouveau.

The lettering on the façade is very delicate, pro- jecting sufficiently from its background to be noticed, and yet dignified in a faintly dramatic manner. It is very much part of the building.

I have developed this letter form in clay, using long thin coils flattened in places and then biscuited and glazed.

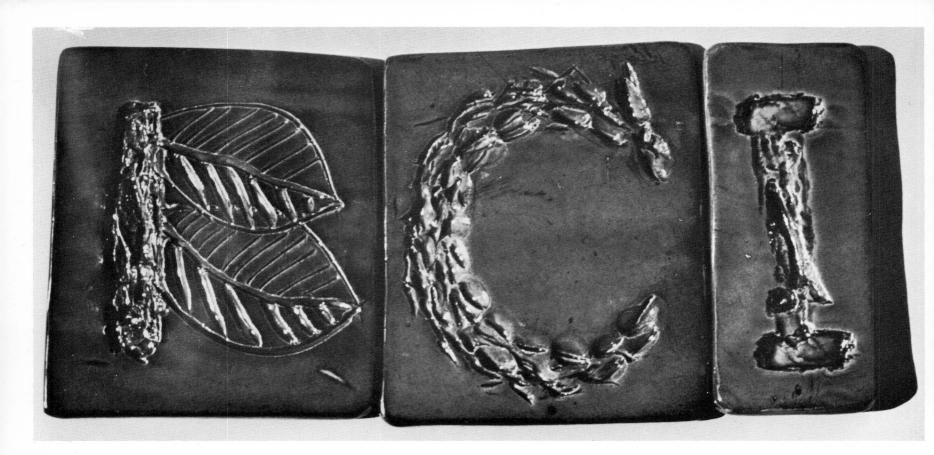

The Grand Theatre Hotel keeps some art nouveau motifs on the façade lettering, and on the tiled entrance panel and mosaic floor. However, it reverts to a rather heavy classical theme above the door and window openings.

I have incorporated the detailed richness from the classical motifs in the modelled letter forms R and J. The piers represent the uprights, the volute replica the full curves, and clusters of leaves and fruit substitute for other less curved parts. Use a little slip to help glue these clusters to the letter forms.

These models should be biscuited, glazed and fired.

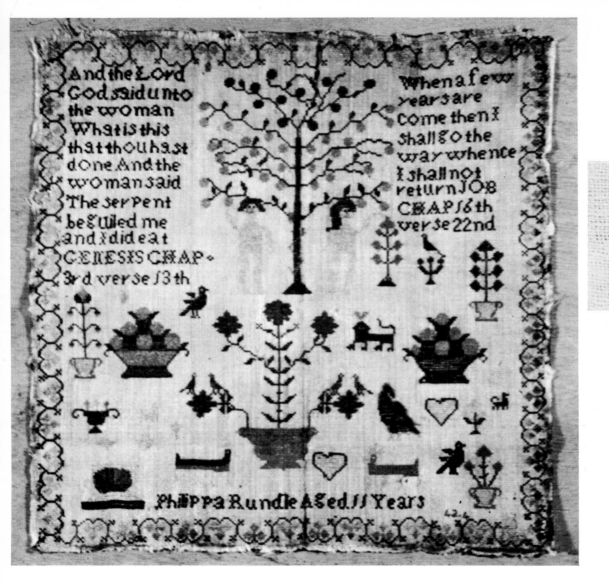

And the Lord
God said unto
the woman
What is this
that thou hast
done And the
woman said
The serpent
beguiled me
and I did eat
GENESIS CHAP.
3rd verse 13th

When a few
years are
come then I
shall go the
way whence
I shall not
return JOB
CHAP 16th
verse 22nd

Philippa Rundle Aged 11 Years

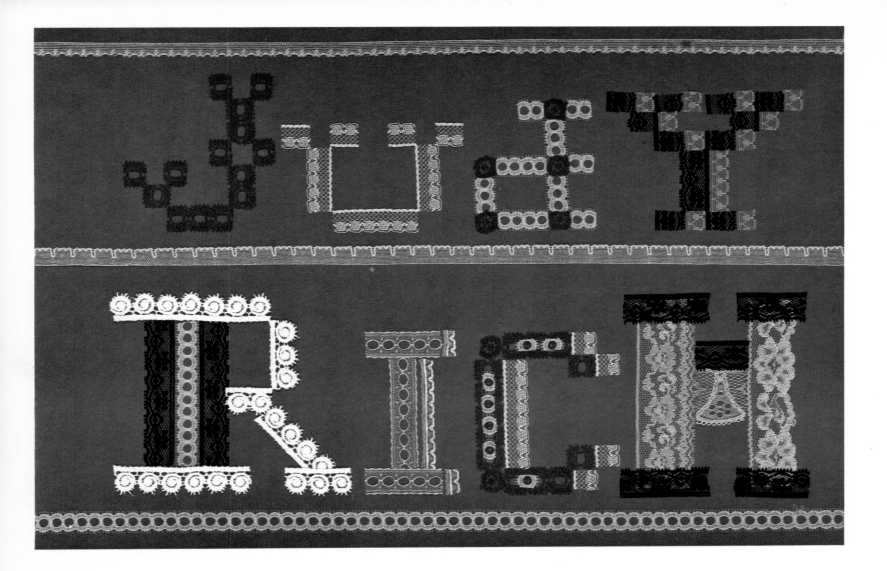

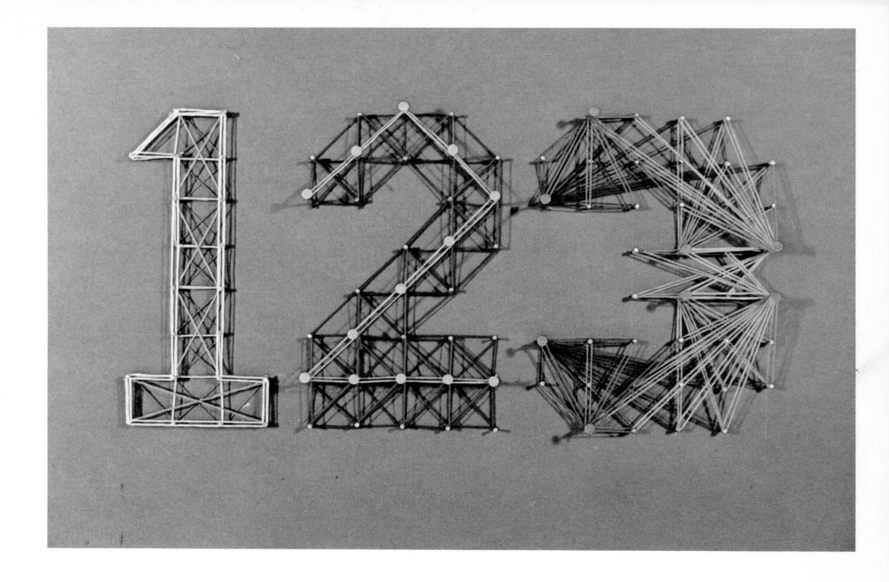

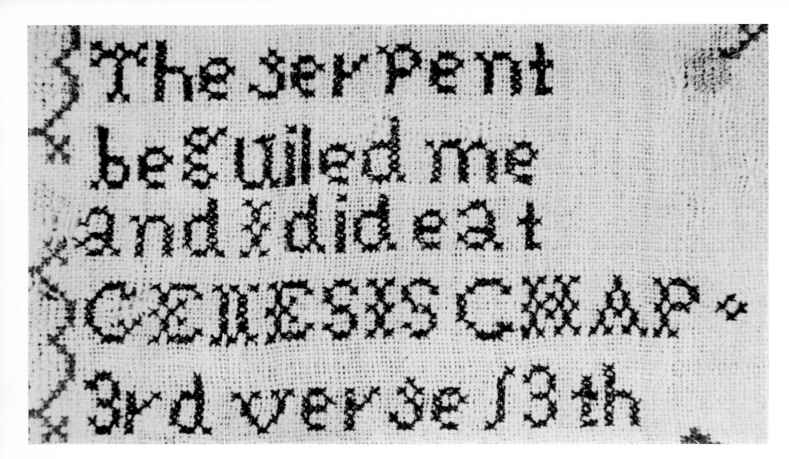

The serpent
beguiled me
and I did eat
GENESIS CHAP.
3rd verse 13th

A fine sampler worked on linen is a difficult thing to achieve. It requires expert needlework, enormous patience, and considerable artistry. The best decorative motifs are both colourful and have great simplicity (page 77).

On any sampler the letter shape and its proportions are based on the linen weave – so many threads high to so many threads wide. Usually the threads are cross stitched, and are occasionally doubled to add thickness or body to the letter.

Partly based on the lacy appearance of the lettering in the sampler and partly on the diagonal stitch structure, I have applied lengths of lace to a coloured paper ground to form the words JUDY and part of RICHARD (page 78). Units of measurement were calculated from the motif of the lace.

The diagonal pattern of threads that forms the basic structure for most lettering on samplers has suggested a three-dimensional departure from the original, as shown with numerals 1, 2 and 3 (page 79). A framework was made from different length nails. A series of coloured threads is then tied up on the framework.

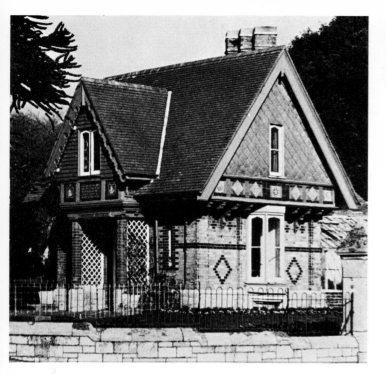

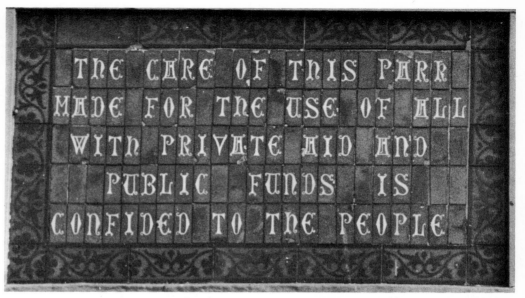

THE CARE OF THIS PARK
MADE FOR THE USE OF ALL
WITH PRIVATE AID AND
PUBLIC FUNDS IS
CONFIDED TO THE PEOPLE

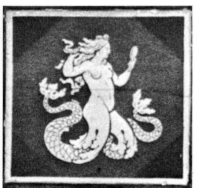

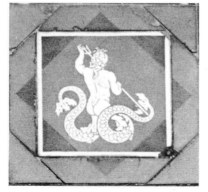

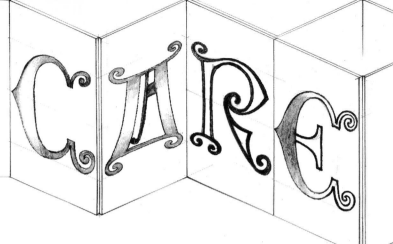

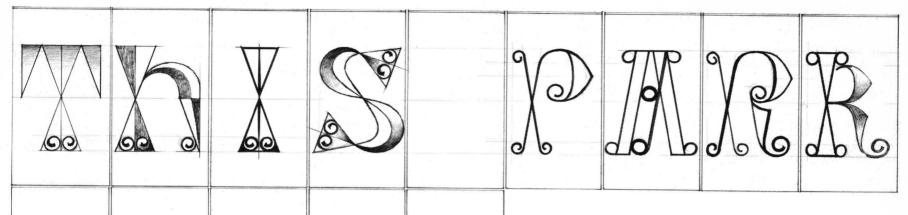

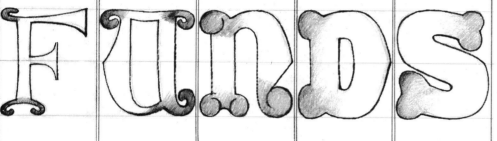

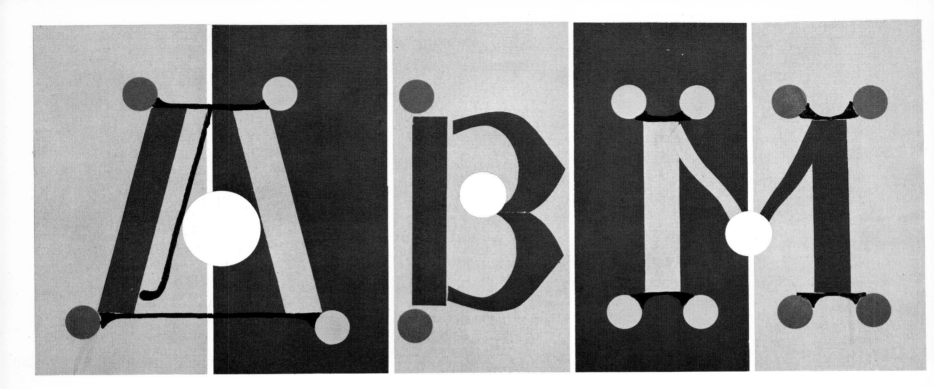

This Victorian house in Plymouth was the residence of the head gardener employed by the Town Council. It has a number of very good tile decorations and some ingenious lettering.

The foliate decoration is in character with its surroundings and the merman and mermaid are appropriate for a building erected by a naval town. The letters, each set on its own tile, are Versal in form and quite legible, done in cream on a brick coloured ground. This method of arranging letters is flexible and makes spacing a simple pro-

cess. Occasionally a character may be fixed upside down, for example the "S" in the SBAD diagonal tile pattern!

Pencil and paint are used to give variations on each letter. These different treatments are each applicable to a full alphabet.

THIS a development based on a constant width measure. It emphasises the waist shape of the uprights but places the curved decoration inside the form. Again each letter is given a different

treatment.

PARK employs a line treatment and simplifies the decoration.

FUNDS shows how a letter can change in appearance by eliminating unnecessary detail as the form gains thickness.

These examples were drawn with a pencil.

You can easily experiment with the Versal letter form, using rectangles, circles, strips and shapes cut out of gummed paper, and inked lines.

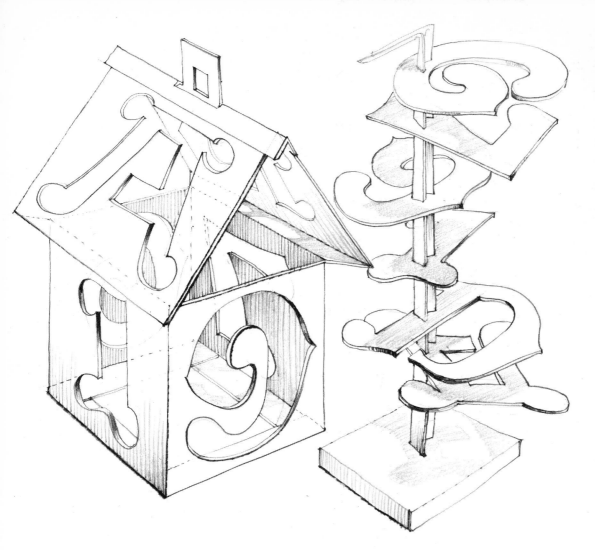

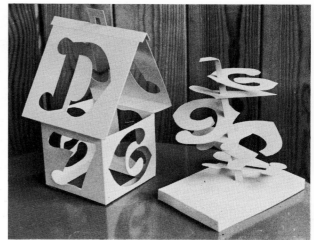

A logical development of the first example is this combination of house, tree, numerals and letters. The simple model of a house made from thin card has A and D on the roof and a numeral on each wall. Cut so the roof and walls remain in one piece; these are then threaded on to a folded length of card which is attached to a card plinth. This offers some resemblance to a tree adjacent to the house.

This is a very free interpretation of the original, that combines the uses of lettering in a lighthearted way. It also opens up the possibility of drawing or painting from the model, or decorating the model structure itself.

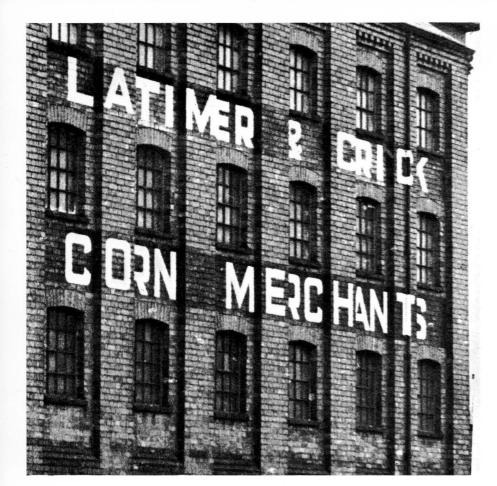

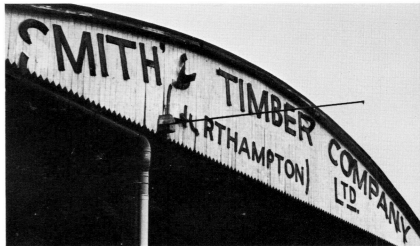

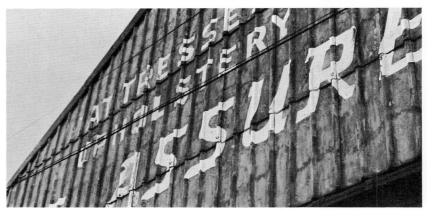

Generally speaking we tend to see only what we expect to see. This is as true of lettering as of anything else and if we stop to consider a letter form, certain idiosyncrasies may become apparent.

I have chosen three examples of lettering from industrial sources that offer possibilities for development. The first example is from a brick-built warehouse. The vertically projecting piers hide parts of the letters when seen from the side but do not destroy their readability. On this accident I have based an arrangement drawn in pencil that runs one letter into another without loss of legibility.

The second example is the name below the curved roof on this building. The letters are cut from timber and weathering has caused them to warp and curl. The result is very interesting and worth experimenting with.

Simple block letters were cut from thin card and the ends curled in various directions. Two pencil drawings were made, viewed from different positions, one using shadow.

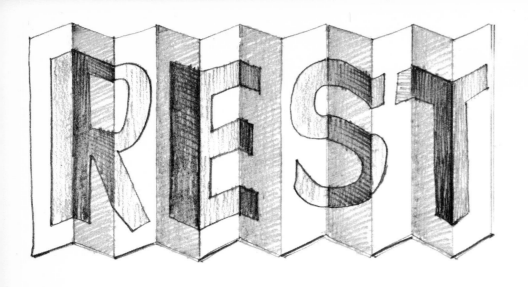

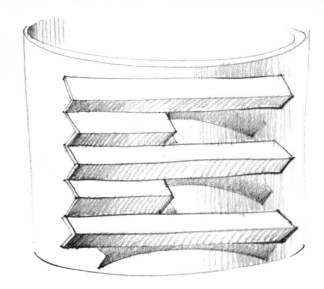

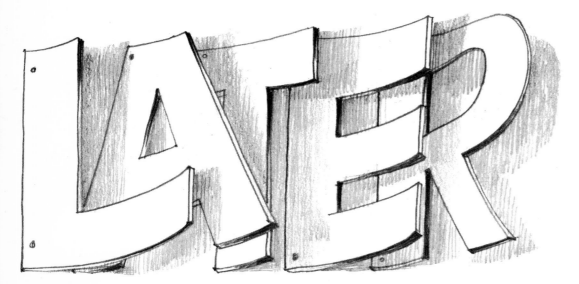

The third example is of a name written on corrugated metal cladding.

This suggested developments that were first cut and assembled from thin card. Next a pencil drawing was made with suitable lighting to cast a shadow. Finally E and R were placed on a mirror surface to make a double image.

Such experiments are simple and inexpensive to produce, and the final drawing or painting will be helped by the understanding gained in making the letters.

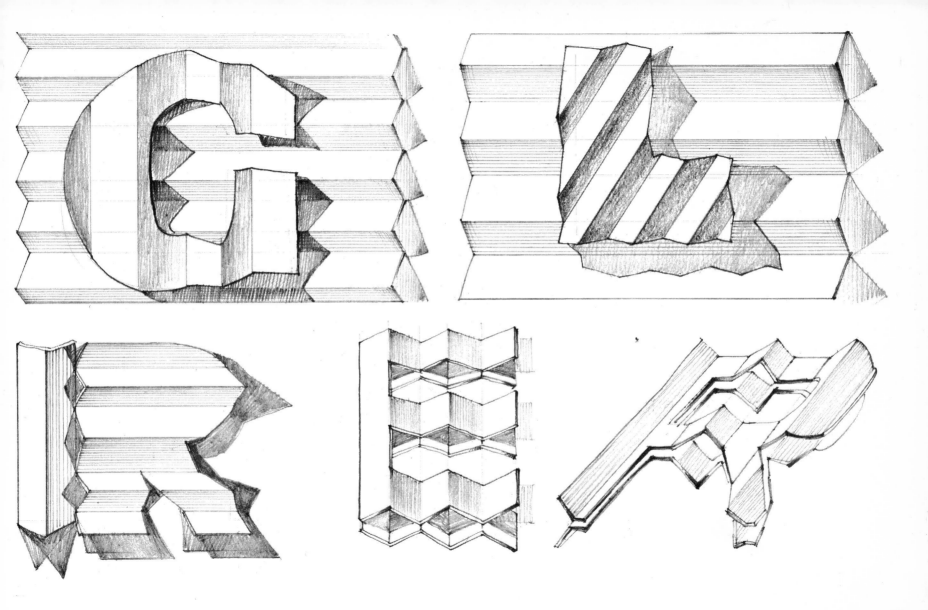

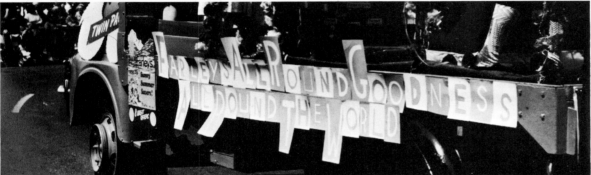

Any procession of decorated vehicles will provide inspiration. I have taken three examples chosen at random and have suggested a development, retaining some of the character of the original.

These letters, decorated with a patchwork of colours, have shapes that expand and overlap with the letter following. With the word CREAMY these characteristics are rationalised. The patchwork pattern was not used because it would have been confusing.

FARLEY'S ALL ROUND GOODNESS shows a simple letter shape finished in grey on white and vice-versa. The letter D has an engaging thick-thin form with the thick part at the top of the curve. The word GREAT plays upon this characteristic with alternate grey and black letters.

The third example is a thin letter decorated with many small flowers and some large butterflies filling the gaps. Sometimes a motif is too small and not used often enough; here the letters should have been thicker and filled with more flowers. The result would have been much richer.

However in developing the motif I have reduced the flower motif to one per letter, but placed it in a position of importance, either terminating a stroke or at the junction of two or more strokes.

These examples are completed in poster colour.

CREAMY
GREAT
garden

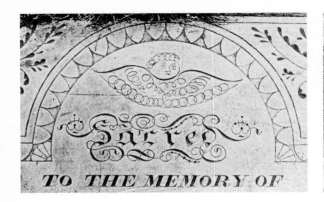

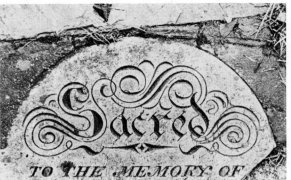

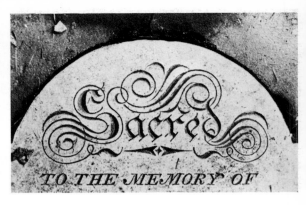

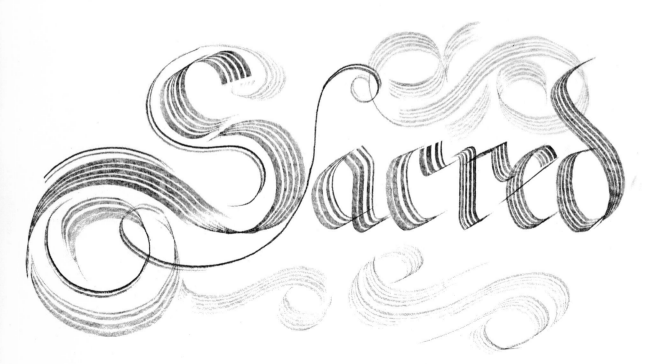

As a final source of lettering I have chosen a churchyard which served a predominantly naval and dockyard community. The headstones are now used to pave the walks through the churchyard and have suffered as a result.

The study of such headstones is very interesting. You can often trace the different interpretation of similar letter forms by rival masons and also detect the less well finished cutting by the apprentice.

These few examples show how a basic letter form, usually drawn in ink, has been adapted for cutting in stone. The beauty of the letter form and the care with which it is executed would suggest that the decoration gave some relief and relaxation to the mason.

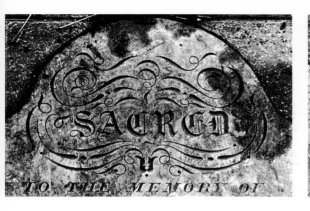
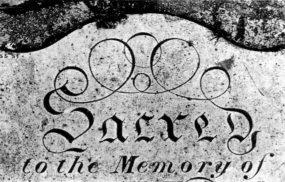
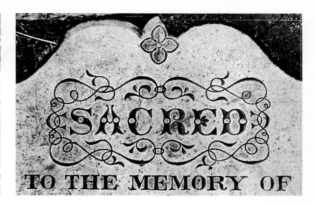

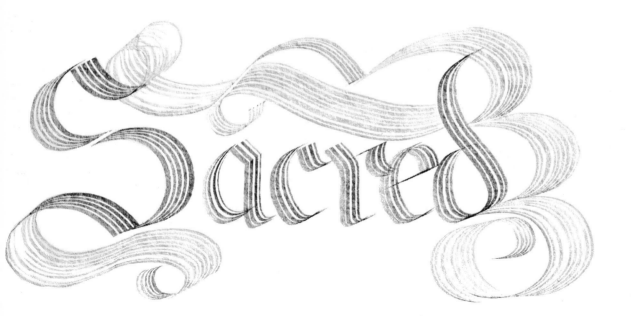

The two examples were written with chalk. A number of gaps were cut into the chalk before it was used. These gaps produce the parallel lines in the letters and the decoration.

R.I.P. (page 96) was freely drawn with three pencils held together. Selected facets were given a line treatment that suggests a similarity to a "V" cut in stone. The headstone and grass are added for good measure!

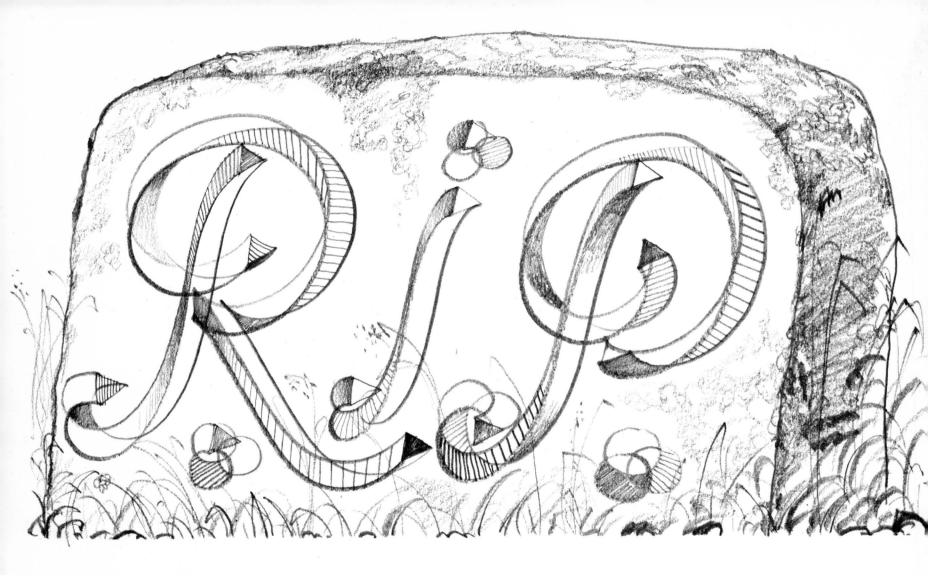